Bible Fun Stuff

FOR PRESCHOOL

Bible Games

THAT TEACH

David C Cook®

transforming lives together

BIBLE GAMES THAT TEACH
Published by David C. Cook
4050 Lee Vance View
Colorado Springs, CO 80918 U.S.A.

David C. Cook Distribution Canada
55 Woodslee Avenue, Paris, Ontario, Canada N3L 3E5

David C. Cook U.K., Kingsway Communications
Eastbourne, East Sussex BN23 6NT, England

Written by Faye Spieker
Cover Design by BMB Design
Cover Photography © iStock
Interior Design by Rebekah Lyon
Illustrations by Aline Heiser
Interior Photography © Gaylon Wampler Photography

ISBN 978-1-4347-6863-6

First Printing 2008
Printed in the United States

1 2 3 4 5 6 7 8 9 10

NICKY PINICNEY

FOR PRESCHOOL
Bible Games THAT TEACH

Table of Contents

Introduction

Preschoolers like to be active. They explore the world by moving. As parents, teachers, older siblings, relatives, or caregivers, we can tap that natural desire to move to help preschool-age children learn. Children learn through movement.

Preschoolers handle, push, pull, and manipulate objects to learn about them and the world. Activity is actually necessary for children's mental development. The amount and meaningfulness of physical participation helps determine how much young children learn and the quality of the information and experience they gain. Movement prepares children for life!

Activities that require hand-eye coordination or the coordinated motion of hands, arms, feet, or legs help develop the right and left sides of children's brains and the critical communication between the two sides. This physiological development is important for children to learn math, reading, writing, and more complex spiritual truths. Jumping, running, hopping, skipping, walking forward and backward, and tossing objects meant for throwing help children develop spatial relationships. Smaller hand motions promote dexterity and coordination needed daily as children grow.

Meaningful movement helps children gain needed experience and knowledge. For preschoolers, this includes awareness of distance and shapes, how to count and the quantities numbers represent, the shape and form of letters and simple words, colors, and truths about their loving heavenly Father. This resource helps prepare the way. So let the learning begin through fun and meaningful activities.

How to Use This Book

Bible Games That Teach guides people who spend quality time with preschoolers to create games and activities that are fun, active, and meaningful for the children. Easy-to-follow directions guide your construction of games that are sturdy for repeated use. The materials are inexpensive and readily available at home or in craft and grocery stores. Storage suggestions are easy and compact. You might label containers for each game using a different color of marker for the type of activity or skill. For example, use a red marker for games that develop math skills, blue for sorting games, yellow for reading, and green for large motor activities.

After construction, use the Bible Background and Teacher Tips sections given for each game to introduce it. Demonstrate how to unpack the game and care for its pieces. Use the How to Play directions to set up the game and teach the rules. Then lead the first few experiences with that game. Finish with instruction on how to pack it into its container. After a few experiences with each game, some children will be able to independently initiate play and teach it to new children.

Each game in this book correlates to the *Bible-in-Life* and *Echoes* Sunday school curriculum for preschool. The games can be used with or without the Sunday school curriculum and in or outside of the church classroom. On page 112 you will find a chart that links each game to the Unit, Lesson, and Scripture of those found in the preschool *Bible-in-Life* and *Echoes* curriculum or for use with any curriculum you choose. The games are versatile and easily adapted for increasing challenge that further develops children's life skills and knowledge about God. Have fun playing, learning, and growing with the children!

Splash and Fly

Bible Background

God made the earth covered with water (Gen. 1:1-2). On the second day of creation, God separated some of the water above the earth from that on the surface of the earth with an expanse between the waters. That expanse is the sky, the place God made for the air we breathe. Not until the third day of creation (Gen. 1:9) did God gather the water on the earth into one place He called the seas. This creative work, accomplished through God's words, allowed dry ground, which He called land, to appear.

Scripture Reference:
Genesis 1:6–10, 20–23

Memory Verse:
God saw all that he had made, and it was very good. Genesis 1:31

God is orderly. He made water and air in preparation for His creative activity that would follow on the fifth day of creation. On this day, God created every living and moving thing that fills the seas and every kind of winged bird that fills the sky.

In Genesis 1, God created birds to fly in the air and fish to swim in the water. God had a plan for the air, birds, water, and fish. God also has a plan for you. God has placed you where you are today for a purpose. Share this with the children you touch today. Don't forget, God has a plan for each one of them, too!

Teacher Tips

"Splash and Fly" is a sorting game that builds fine motor control with the hands as well as familiarity with the animals and objects God made for the water and the sky. Every child's turn presents a sorting decision that develops abilities to organize and apply information.

The game also provides opportunities for questions and conversation about how God created the water and sky and the animals and objects He placed in each. Ask questions freely. Encourage the children to share their knowledge and experience with what God created. Provide opportunities for them to talk. Be patient as children develop the small motor control and steady hands to place the sticks into the mouths of the bird and fish.

Get It Together

- ☐ 10 to 20 craft sticks
- ☐ Stickers of animals filling the sky and sea plus sun, moon, stars, clouds, and lightning
- ☐ 1 small resealable bag
- ☐ Two 12-oz. water bottles, emptied
- ☐ Green craft foam
- ☐ Yellow, green, and blue adhesive craft foam
- ☐ Scissors
- ☐ Craft glue
- ☐ Colored permanent markers or paint
- ☐ Box with resealable lid

How to Assemble

1. Put a sticker on one end of each craft stick. As an alternative, cut adhesive craft foam to make animals and other objects God created in the water and sky to substitute for stickers.

2. Collect all completed sticks in the resealable bag.

 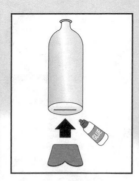 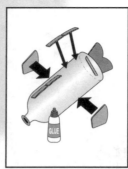 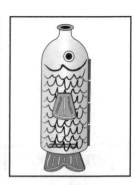

Make a Fish:

3. Cut green craft foam in the shape of a fish's tail.

4. Cut a slit in the bottom of one empty water bottle. Insert the tail into the slit. Secure the tail to the bottle with craft glue.

5. Discard the bottle lid to leave the bottle open for the fish's open mouth.

6. Cut two side fins and two 1" x 4" strips from green adhesive foam.

7. Stick one fin on each side of the empty bottle and the strips end-to-end lengthwise as if the top of the fish.

8. Use markers or paint to color eyes and scales on the fish.

 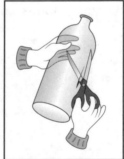 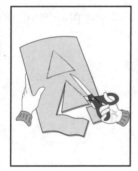 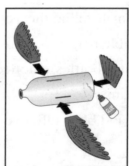 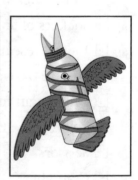

Make a Bird:

9. Cut blue adhesive foam in the shape of a bird's tail and two wings, plus one ½" x 6" strip, and two 1"x 4" strips. Use marker or pen to draw feathered texture on all pieces.

10. Discard the bottle lid to leave the bottle open for the bird's open mouth.

11. Cut a lengthwise slit in each side of the bottle to insert the wings. Secure the wings to the bottle with glue. Glue the tail upright on the bottom of the bottle.

12. Cut a pair of 3" triangles from yellow craft foam. Attach to the bottle opening as the bird's beak leaving the mouth open and accessible.

13. Wrap the blue ½" x 6" strip around the bottle beginning at the base of the beak and working toward the tail. Draw eyes to complete the bird.

14. Collect all game materials into a resealable box labeled, "Splash and Fly: sorting, small motor coordination."

How to Play

1. Unpack the materials placing the bag of craft sticks, bird, and fish in front of the children.

2. First child draws a stick from the bag and tells what the sticker on the stick shows.

3. The child puts a craft stick showing something God made for the water into the mouth of the fish or a craft stick showing something God made for the sky in the bird.

4. Children take turns repeating steps 2 and 3. When all craft sticks have been sorted, empty the bird and the fish and play again.

Game Wrap-up!

• **What can you see in the sky that God made?** *(sun, moon, stars, clouds, rain, snow, lightning, etc.)*

• **What did God make to live in the water of lakes and seas?** *(fish, whales, etc.)*

Let's thank God for everything He made to fill the sky and water.

Dear God, thank You for the many different things that are in the water. Thank You for the blue sparkles and lovely wet splashes that come from water. Thank You for the many different kinds of creatures that we see in the sky. How fun to feel the cool wind on my cheeks and see the fluffs of white clouds floating by. We love You. In Jesus' name, amen.

Stripes, Splots, and Polka Dots

Bible Background

God created animals that live on the land on the sixth day. He made them according to three kinds: livestock, creatures that move along the ground, and wild animals.

As He did with the rest of His creation, God saw the animals were good. This goodness gives Him glory. Their lives and the unique or distinctive character God gave each kind pleases Him. The vast diversity of animals reflects God's creative imagination.

Even with the tremendous differences among the creatures, God provided everything each animal needs. David confirmed this, praising God who satisfies "the desires of every living thing," (Ps. 145:15-16). Psalm 104 is a hymn to the Creator declaring a few examples of God's provision—trees for birds to nest in and high mountain crags for alpine animals (Ps. 104:17-18). Through His omniscient master plan for the world, God had already prepared the earth before the sixth day of creation to provide food and shelter for every kind of animal.

God created a vast array of animals. Each one has unique characteristics to help it survive in its environment. The giraffe has its unique long neck to reach the tree leaves. The walking stick can camouflage itself to hide from predators. Just looking at animals can be a testimony of God's greatness as the Creator. How would you describe your Creator? How would you describe Him to the kids you teach today?

Scripture Reference:
Genesis 1:24-25, 30;
Psalm 104:10-12, 17-18

Memory Verse:
God saw all that he had made, and it was very good. Genesis 1:31

Teacher Tips

"Stripes, Splots, and Polka Dots" engages the children in an exploration of the different skin and fur God gave animals when He created them. During the activity, ask the children to tell about the different colors, patterns, and textures they see in the animals on the picture cards you make and the similarities to your pattern plates. Help, as needed, to develop vocabulary and to compare and contrast characteristics of the animals in your pictures and the color, texture, and pattern in the pattern plates. Skills for pattern recognition support strong math and reading ability.

During and after the game, talk with the children about why God might have made animals with different, colors, texture, and patterns in their skin or fur. For example, these features make them beautiful and different but also help them look like the places they live such as green grass, desert sand, grey rocks, or white snow so they can blend in and hide.

Get It Together

- ☐ Squares of fake fur or felt for 6 different animal-skin patterns available from most hobby supply stores
- ☐ 6 wicker paper-plate holders
- ☐ Pictures of animals from magazines or the Internet with skin or fur that has similar color, texture, or pattern as your fur or felt patterns
- ☐ Scissors
- ☐ Poster board
- ☐ Glue sticks
- ☐ Craft glue
- ☐ Large resealable bag
- ☐ Optional: Clear adhesive paper or laminator

How to Assemble

1. Cut fur or felt pieces to fit into wicker paper-plate holders and then glue each piece inside a holder to make six different animal-skin pattern plates.

2. Glue animal pictures to the poster board. Then cut out each leaving a 1/3" border of poster board around each picture to make animal picture cards.

3. Optional: Cover each animal picture card with clear adhesive paper or laminate.

4. Collect animal cards and animal-skin pattern plates in a resealable bag labeled, "Stripes, Splots, and Polka Dots: pattern recognition, object comparison, vocabulary development."

How to Play

1. Open the game bag and spread the animal cards picture side down in front of the children. Spread the animal-skin pattern plates within reach of the children.

2. The first child selects an animal card and looks at the picture to match the color, texture, or pattern of the animal's skin to the most similar animal-skin pattern plate.

3. Ask the children to explain the similarities between the animal shown on the card and the skin pattern, color, or texture shown on the pattern plate.

4. Have all the players stand up and move in place or wiggle to demonstrate how the animal on the card moves.

5. Repeat steps 2, 3, and 4.

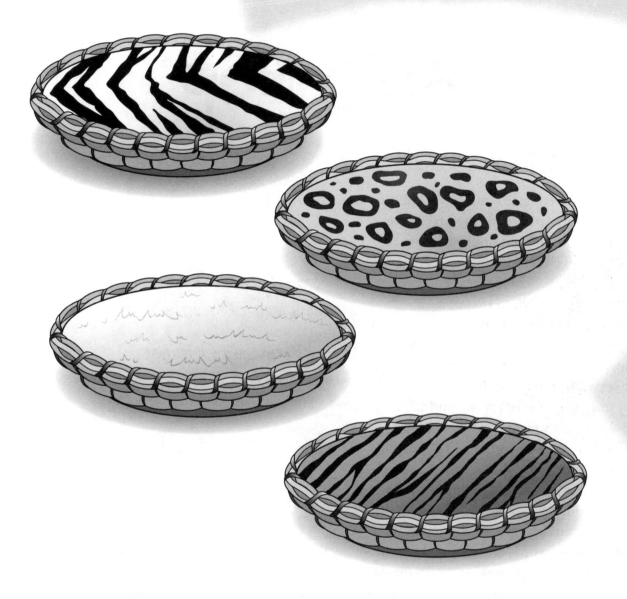

𝒢ame 𝒲rap-up!

- **What kinds of animals do you like best?**
- **Can you show me what that animal looks and sounds like?**
- **Who made all the animals?** *(God did.)*

Dear God, thank You for making the animals. We praise You because You are so creative, making so many animals, and they are all so different. We love the animals, and we love You. In Jesus' name we pray, amen.

Body Hop

Bible Background

"Let us . . ." (Gen. 1:26) indicates God the Father, Son, and Holy Spirit convened to create people. To our limited understanding, it was a creative committee. The word *formed* (Gen. 2:7) compares God's creative work to that of a potter shaping a piece from clay. The potter determines the shape and unique character of the vessel. God formed the man from the dust of the ground and the woman from Adam's rib. Both works were creative processes of shaping the head, face, neck, torso, arms, hands, legs, and feet, as well as giving character to each person.

Scripture Reference:

Genesis 1:26-29, 31; 2:7-8, 21-23

Memory Verse:

The LORD is God. It is he who made us.
Psalm 100:3

God created people in His image, or likeness; these words are synonyms in the Bible. Every person is worthy of respect and honor because he or she is made in God's image.

God breathed life into people. The breath of life gives us a measure of affinity with the animals—which also have the breath of life (Gen. 1:30).

God made people for a purpose—to rule over all the creatures and the earth (Gen. 1:26, 28). Exercising dominion appropriately is one way we honor God and give Him glory. God also provided for our needs—the fruit of the trees and plants (Gen. 1:29) and companionship of a man and a woman raising families to fill the earth.

What do you see when you look in a mirror? Do you see every imperfection? God created you and blessed you and provides for your every need. He has given His "stamp of approval" on His special creation. What you see in the mirror is someone unique. Despite what you see as "imperfections," there is something special about you. God has made you; He designed you to be His special child. Remind your children today how special they are—God says so!

Teacher Tips

"Body Hop" gets the children actively involved using large motor skills while cementing the truth that God made us and also learning about and reinforcing their knowledge about their bodies.

Every child's turn will give you plenty of opportunity to reinforce that God made our bodies, creating our hands, eyes, arms, legs, and so on. Extend the learning experience by talking with the children about how they use each of the body parts God gave them when He made them. We can use them to care for the earth and give Him glory.

Get It Together

- ☐ White or other light color vinyl tablecloth
- ☐ 1 extra-sturdy 12" paper or plastic disposable plate
- ☐ Brass paper fastener
- ☐ Paperclip
- ☐ Permanent markers
- ☐ Ruler
- ☐ Large resealable bag

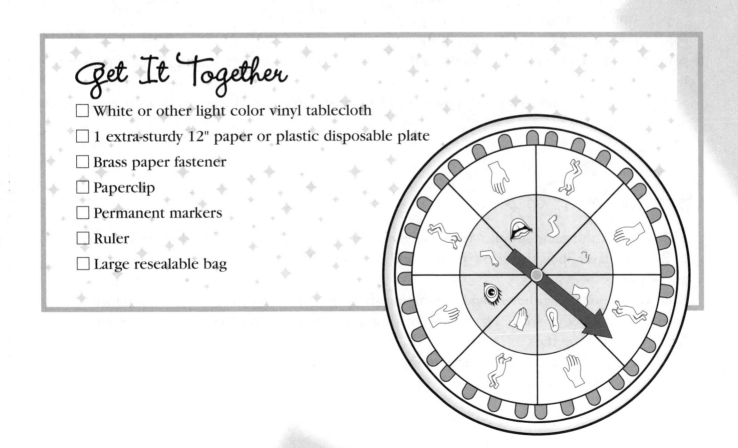

How to Assemble

1. Draw an outline of a body on the table-cloth clearly including fingers, elbows, knees, and toes. Draw eyes, nose, mouth, and ears.

2. Use the ruler to draw straight lines making eight equal-size, pie-shaped sections on the plate.

3. Draw a body part into each section: eye, ear, mouth, nose, foot, hand, elbow, and knee. Draw a circle around these pictures.

4. Draw a small hand at the outer edge of the sections with the eye, nose, ear, and mouth.

5. Draw a stick figure of a jumping man at the outer edge of the sections with the foot, hand, knee, and elbow.

6. Make a pin-sized hole in the center of the plate. Insert a brass paper fastener through the small loop of a large paper clip. Insert the paper fastener through the hole on the plate so that the paper clip is on the top of the plate. Flatten the paper fastener ends on the back side of the paper plate. The paper clip should be able to spin easily.

7. Collect your tablecloth and spinner in a large resealable bag labeled, "Body Hop: large motor and jumping skills."

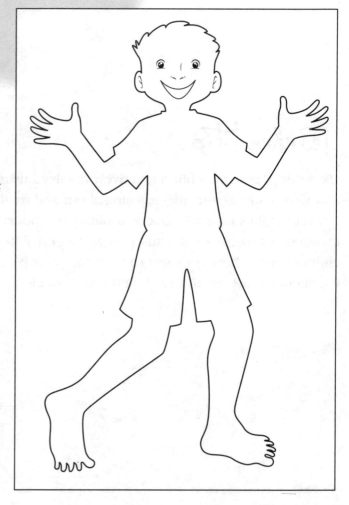

How to Play

1. Unpack the game supplies from the game bag. Lay out the body tablecloth and the spinner.

2. First player spins the arrow pointer and names the body part shown in the circle that the arrow points to.

3. Child looks for either a hand or jumping stick figure to determine if he or she pats the corresponding body part (if a hand is shown) or hops on the corresponding body part (if stick figure is shown) on the tablecloth.

4. Child hops over to pat or jump on the correct body part.

5. Next player repeats steps 2–4.

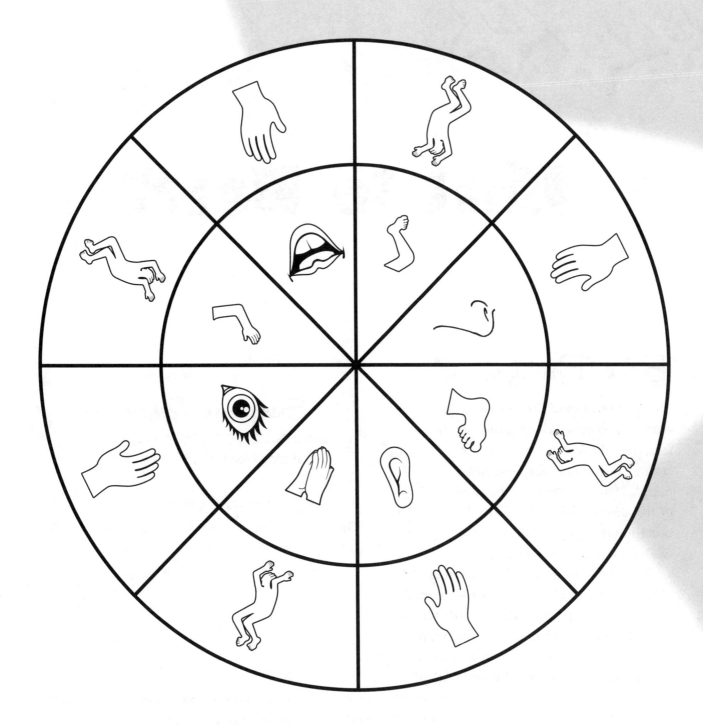

Game Wrap-up!

- **Who made us?** (*God made us.*)
- **What are some good things about you that God made?** (*Let the children talk or point to body parts so they can name what God gave us—legs for jumping, voices for singing, hands for clapping, ears for hearing, eyes for seeing*)

Dear God, thank You for making me. You have given to me just what I need. Help me to use all that You've given me to do good things. I love You. In Jesus' name, amen.

What to Wear?

Bible Background

God created man in His image. The emphasis is on God's creative act. In fact, the Old Testament word for *create* is used only for God, not people. After forming the man out of the dust of the earth God breathed life into the flesh. It is God alone who gives life.

God made people male and female. We get a glimpse of God's purpose—the male and female are companions (Gen. 2:18) who fulfill a role in God's continued creative plan. Eve's name, given by Adam, hints at that creative plan. That plan begins to be fulfilled in Adam and Eve's family, but only "With the help of the LORD." Eve declared God is the Creator, the source of life (Gen. 4:1). Eve knew she was the vessel God used while completing the work.

God's personal creative work extends to each person. He brings forth our being as if knitting us together in our mother's womb (Ps. 139:13). It is because of God's work that we are wonderfully made—in unique external character, our distinct abilities for exercising dominion, and our "inmost being" or moral sensitivity.

God's knowledge about us is far beyond human capacity (Ps. 139:6). He knows our thoughts (vs. 2), our ways (vs. 3), our words (vs. 4), and our days (vs. 16). No one else knows all this about us.

Your body is more than a mass of muscles, nerves, and organs. Even if you feel it has imperfections, your body is a sacred place, a dwelling place for God. With God's perspective on your body in mind, praise God for His wonderful creation.

Scripture Reference:
Genesis 1:27; 2:7; 3:20; 4:1-2;
Psalm 139:1-6, 13-18

Memory Verse:
The LORD is God. It is he who made us.
Psalm 100:3

Teacher Tips

Hats off to this hands-on game! "What to Wear?" helps children explore with their teachers the awesome wonder of our bodies that God made. The game presents a fun and concrete setting for the children to learn and reinforce their knowledge about their bodies and the world.

At each turn, children select a picture showing part of a person's body and then sort clothing to select a corresponding article. Allow the children uninterrupted time to think so they can evaluate and eliminate options down to a final match. This cognitive process builds thinking skills that will be critical as they continue growing.

Once a match is completed, ask the child what body part is shown on the picture card and where the corresponding piece of clothing is worn. Talk with the children about how we use the parts of our bodies God made to play and work.

Get It Together

- ☐ Various pieces of clothing (kids' sunglasses, pants, shirt, skirt, kids' flip-flops, glove, mitten, various hats, earmuffs, kneepad, scarf, bracelet, ring, etc.)
- ☐ Poster board
- ☐ Black marker
- ☐ Scissors
- ☐ Clear adhesive paper or laminator
- ☐ Optional: glue and magazines with pictures of people
- ☐ Shopping bag

How to Assemble

1. Collect suggested articles of clothing. Second-hand stores will have these items.

2. Draw or glue pictures of a person's head and neck, upper body with head and arms, feet and ankles, hands and wrists, plus waist and legs on the poster board.

3. Cut out the pictures from step 2 and cover with clear adhesive paper or laminate.

4. Collect clothing and body pictures in a shopping bag labeled, "What to Wear?: sorting and matching."

How to Play

1. Spread articles of clothing in one area and body pictures (picture side down) in another area in front of the children.

2. The first child playing selects a body picture card, looks at the picture, then sorts through the articles of clothing to match a piece of clothing worn on the part of the body shown.

3. Child holds the article of clothing matched and returns the card, picture down.

4. Second child repeats step 2 above.

5. Continue play. When a child cannot match an article of clothing to a body picture card then the teacher should remove that card from play and let the child select again. Play until all articles of clothing are matched.

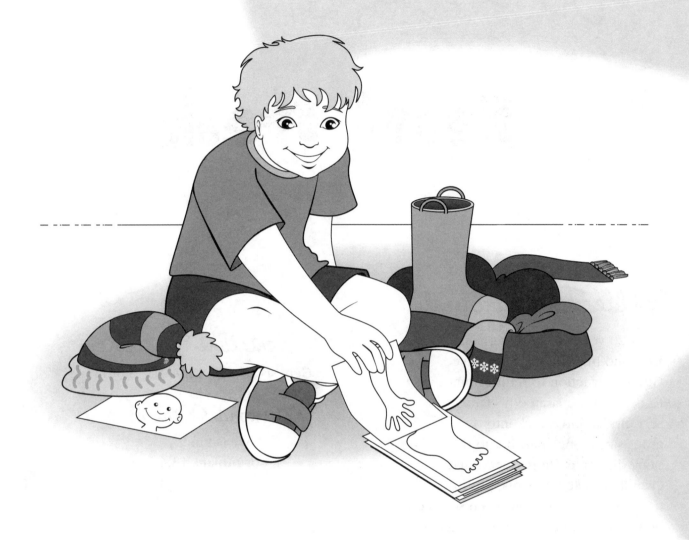

Game Wrap-up!

- **What did God make?** *(God made our bodies.)*
- **How do you use your legs?** *(to walk, run, skip, hop, kick a ball, etc.)*
- **Why do you think God gave us ears?** *(to listen to one another, music, birds singing, the wind blowing, God, etc.)*

Let's use our hands to clap or stomp our feet to thank God for making us. Let's use our voices to shout praise to Him. Yahoo, God, You are great!

Dear God, thank You for making our bodies with arms, legs, ankles, knees, and toes. Thank You, God, for ears, eyes, smiles, and not more than one nose. With everything we have, we praise You! We love You! In Jesus' name we pray, amen.

Heart Break

Bible Background

After 20 years in Haran, far away from Esau and his wrath, Jacob obeyed God's instruction to return home to Israel. He separated his family, servants, and livestock into two groups traveling apart but in the same direction. He reasoned that even if Esau attacked one group, the other would be safe. Even so, Jacob was concerned that Esau remained angry and would attack him and his family. Jacob confessed his fear to God and asked for His protection (Gen. 32:11). This was a way of asking God to help them get along. God did protect Jacob by helping Esau and Jacob to reconcile. But it wasn't automatic; God worked over a period of time to reunite the brothers.

Scripture Reference:
Genesis 27:41a; 32:9–21; 33:3-11

Memory Verse:
Love is kind.
1 Corinthians 13:4

First, God blessed Esau (Gen. 33:9). Esau obtained wealth and plenty—even without his father's blessing—and this helped him to forgive Jacob. Second, Jacob knew he was wrong to take their father's blessing from Esau. Upon return, Jacob reversed that act in a different and symbolic way, giving back the blessing through possessions God had given him. This is why he selected a sizable gift of livestock for Esau (Gen. 32:13). In addition, Jacob expressed the new humility in his heart through the messages he sent to Esau, referring to himself as "your servant Jacob" Genesis 32:18, 20). Then as he approached Esau (Gen. 33:3), he bowed to the ground before him—commonly recognized throughout the ancient world as a sign of total submission.

Through the work God accomplished in both Esau and Jacob, He helped these brothers forgive each other and get along.

Teacher Tips

"Heart Break" is a game for several children to do at one time. It requires the children to get along while working together to complete puzzles.

The children develop finger dexterity by manipulating puzzle pieces and large motor control by moving pieces from one area to another while gaining special awareness of angular lines and recognition of alphabet letters.

When introducing the game remind them that when we have a fight with someone it can break our heart, but forgiveness can heal.

Get It Together

- ☐ Five red craft-foam sheets
- ☐ Scissors
- ☐ Black permanent marker
- ☐ Large resealable bag

How to Assemble

1. Cut a large heart from each sheet of red craft foam. *(Hint: It's easy to cut a well-shaped heart by folding each craft-foam square diagonally and cutting half of a heart starting from the fold on top and ending at the fold on the bottom.)*

2. Print an uppercase A and lowercase a side by side (A,a) on each hump of one heart. Repeat for letters B through E on the other four hearts.

3. Optional: For more advanced children, place uppercase letters on one side of each heart and the corresponding lowercase letter on the other side.

4. Draw a jagged line down the center of each heart. Vary the angles and lateral lengths to make each jagged line obviously different.

5. Cut along the jagged line on each heart.

6. Collect the 10 pieces into a large resealable bag labeled, "Heart Break: matching, spatial recognition, letter identification, finger dexterity, large motor skills."

How to Play

1. Open your game bag and spread the heart pieces in front of the children, letter side up. (If using the more advanced option in assembly step 3, have the children flip pieces as needed to have all capital letters or all small letters up.)

2. Tell children to repair the broken hearts by matching the letters and the center lines.

3. Play again as time allows.

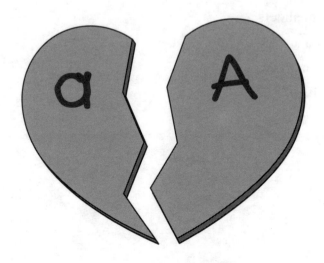

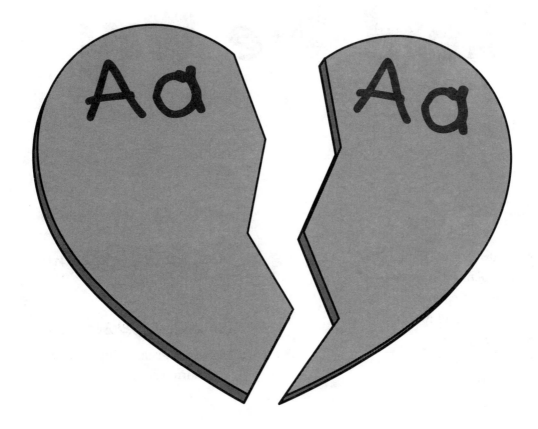

Game Wrap-up!

• **God helps us get along with each other. He helps us get along by helping us learn to listen to one another. When did you listen to one another while playing Heart Break?** *(Let the children respond. Suggest actions you saw and things you heard.)*

• **God helps us get along by teaching us to share with one another. What are some things you can share?** *(toys, snacks, love, friendship, etc.)*

God can help us get along. Let's thank Him for helping us get along. Dear God, thank You for helping us get along. In Jesus' name we pray, amen.

Lead the Way

Bible Background

Joseph not only interpreted Pharaoh's dreams but also explained why two dreams had the same message— God would certainly act. Pharaoh sought someone like Joseph— someone who was filled with God's Spirit—to lead the plan Joseph suggested.

Scripture Reference:
Genesis 41:28-55

Memory Verse:
The Lord has done great things for us.
Psalm 126:3

God had developed leadership qualities and wisdom in Joseph. Through these qualities, Pharaoh, a pagan, recognized God's presence and power in Joseph.

The ring (Gen. 41:42a), robe, and chain (vs. 42b) all signify royal authority and thus leadership. When Pharaoh gave these, he visibly transferred authority for leading, making Joseph a vizier—the highest executive immediately below the king. Anyone listening to Joseph's directions would be able to clearly notice the ring, robe, and chain and know that his words carried Pharaoh's command.

There is no hint of any rebellion when Joseph took food from the people to store away, even when the supply piled up through seven years of collection. We may attribute this first to the quality of Joseph's leadership and secondly to the authority bestowed on him by Pharaoh.

In Old Testament times, people were sometimes renamed for their accomplishments. Joseph's Egyptian name, Zaphenath-paneah, might mean "a revealer of secrets." This is reasonable because it reflects how Pharaoh benefited from Joseph. However, as we know from the rest of the story, God made Joseph a leader to care for His people. Pharaoh and the rest of Egypt were merely benefactors of God's mercy.

Teacher Tips

"Lead the Way" is a large motor jumping game for two or more. It builds decision-making skills for leading and listening/observing skills for following. Both sets of abilities are critical for child development, and preschoolers are ready to accomplish some of that maturation.

Guide or direct the leader to place the carpet pieces in an arrangement where choices are necessary. That is, a child could reasonably jump to more than one alternative. This will create decision points for the leader or impress the importance of listening for others to follow correctly.

Game play also reinforces familiarity with shapes and requires children to memorize a sequence for a short term. The latter, especially, is an important skill for success in the classrooms of school and everyday life.

Get It Together

☐ 5 short-pile carpet squares from clean, used carpeting available at carpet stores

☐ Thick-point black permanent marker

☐ Self-adhesive, non-skid carpet backing

☐ String, tape, notepaper, and pen

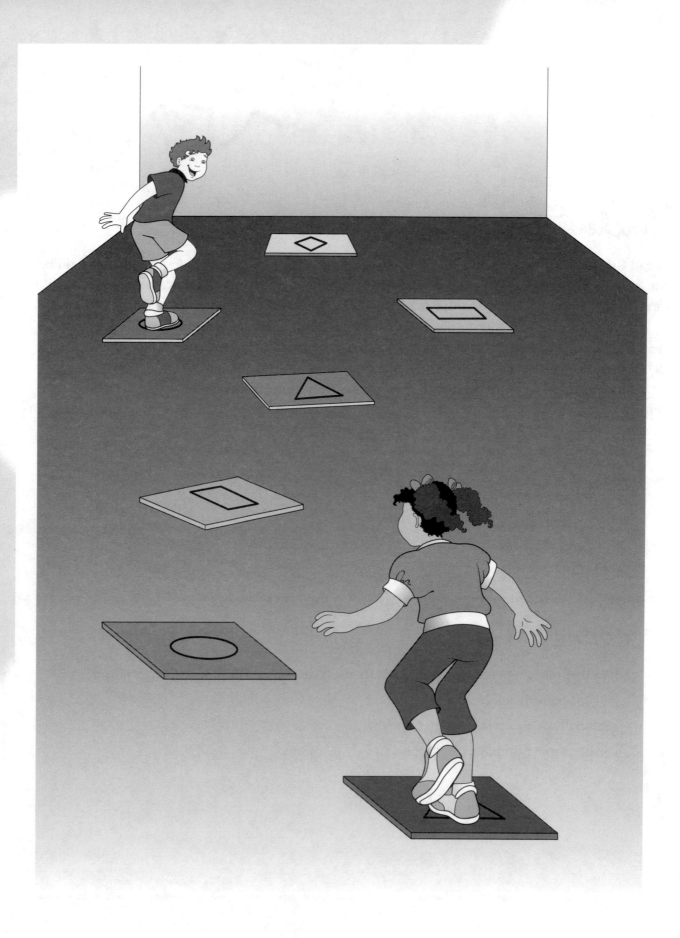

How to Assemble

1. Draw one large rectangle on a carpet square.

2. Repeat step 1 except draw a square, a circle, an oval, and then a triangle on the other carpet squares.

3. Attach nonskid carpet backing to the bottom of each square.

4. Stack the carpet pieces and bundle with string. Tape a note to the string labeling the bundle, "Lead the Way: large motor jumping, decision-making, and listening/observing."

How to Play

1. Have your youngest child "Lead the Way" by placing the carpet squares in a group on the floor.

2. The same child jumps from one carpet square to another calling out the names of the shapes as he or she jumps from one to another.

3. The next child jumps from carpet square to carpet square following the leader's same path and calling out the names of the shapes while jumping one to another.

4. Repeat step 3 for all the children playing.

5. Assign a new leader who leads the way beginning at step 1.

Game Wrap-up!

- **When people needed food, God made Joseph a leader who took care of the people and provided food. Who provides food for you?** (*parents, mom, dad, etc.*)

- **Who are some other leaders you can name?** (*grandparents, older sister/brother, babysitter, teacher, etc.*)

God made our parents the leaders of our families to take care of us. We all have leaders at school, work, church, and of our country. God also gives us these leaders to take care of us. Let's thank God for the leaders He gives.

Dear God, thank You for giving us leaders to take care of us. Please help our leaders do a good job. We love You. In Jesus' name, amen.

Prayer Chain

Bible Background

God chose King Solomon to build the temple (2 Sam. 7:12–13). It took seven years to complete the building. Eleven months after the completion, Solomon gathered the people to dedicate the temple as a place for God to dwell among His people. Priests carried in the Ark of the Covenant and placed it in the Most Holy Place beneath the cherubim wings. When the priests left the room, a cloud called the *Shekinah Glory* filled the temple. The cloud was a physical demonstration showing that God dwelled with His people.

Scripture Reference:
1 Kings 8

Memory Verse:
Worship the Lord.
Psalm 96:9

Solomon addressed the people (1 Kings 8:15–21) then led them in a prayer of dedication. He praised God for His supremacy and love (vs. 23), for keeping His promises (vs. 24), for His presence which cannot be contained even within the temple (vs. 27), and that He listens.

Solomon continued with seven petitions for mercy for the people when they needed forgiveness, if they suffered captivity, for protection from drought and plague, when they experienced famine, that foreigners in the land would believe, for military troops in distant lands, and if the people ever had to go into exile.

Solomon praised God for His greatness before Israel in 1 Kings 8. Not only did he understand the importance of prayer, but he also knew the value of praying with others. There is a heightened sense of God's power and encouragement when people pray together. It is a special way Christians can worship God. What about praying together with your class today?

Teacher Tips

"Prayer Chain" allows opportunities for children to develop their finger coordination by connecting the ends of felt strips to make loops and then linking those loops to make chains.

This is also a great activity to help small groups of children learn cooperation. Supervise the children to help them take turns connecting color loops in patterns. Pattern construction helps build critical sequencing skills necessary for math and reading success. Cooperation will stretch the children to notice others, listen to them, and allow others to have a turn.

We can help children learn by praying aloud in their presence and then inviting them to repeat after us. "Prayer Chain" can provide many prayer prompts—perhaps too many for some children. Limit the topics for prayer to one or two loops in a prayer chain when introducing the game, especially for younger children. As children gain more experience with the game and prayer, expand the number of topics highlighted in chains and your conversation with the children.

Get It Together

- ☐ 9" x 12" felt sheets in 3 different colors
- ☐ Scissors
- ☐ Ruler
- ☐ Hook and loop fasteners, ½" round
- ☐ Craft glue
- ☐ Permanent marker
- ☐ Optional: stickers showing things we might pray about or thank God for: happy, sad, or angry faces; food and water; home; clothes; sick child in bed; etc.
- ☐ Large resealable storage bag

How to Assemble

1. Cut felt into 2" x 12" strips

2. Glue hook and loop fasteners to each end of the strips so each strip may be fastened to make a loop.

3. Print the word *pray* on both sides of each strip and draw a picture or glue a sticker showing things we might pray about or thank God for.

4. Collect completed felt strips in a resealable bag labeled, "Prayer Chain: finger coordination, pattern/sequence, cooperation."

How to Play

1. Empty your game bag and show the children how to fasten the hook and loop pieces at the end of each strip to make loops.

2. Show the children how to link two loops to make a chain.

3. Let the children continue linking loops to make a chain.

4. Show the prayer pictures on a few loops and talk with the children about how each shows something we might pray to God for or about.

5. Pray through part or all of your chain with the children.

6. For more challenge, ask the children to make chains in a sequence of colors in patterns.

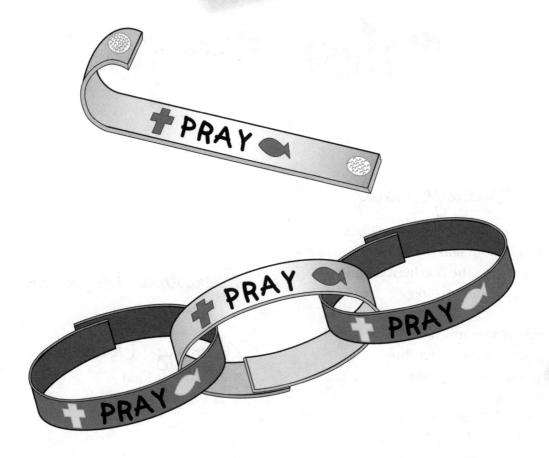

Game Wrap-up!

• **When can you pray?** *(at lunchtime, at bedtime, when I get up, at church, etc.)*
• **What can you ask God for?** *(help, food, healing, etc.)*
• **What can we thank God for?** *(mommy, daddy, family, cat, dog, new toy, food, friends, etc.)*

Prayer is a way we worship God together. We can ask for God's help, and we can thank God too. Let's do that now. Jesus, we ask You to help us, and we thank You for our families and friends and food and all You give us. In Jesus' name, amen.

Color Bingo

Bible Background

Elisha, the anointed successor of Elijah, served Israel through the reigns of six kings. He occasionally traveled to the northern kingdom of Israel to share information about God.

Prophets of this time often traveled from place to place, but they were responsible for their own food and shelter. People who appreciated the prophet's ministry in their communities would be nice to the prophets and invite them for meals and/or lodging.

A well-to-do woman appreciated Elisha's ministry in Shunem and demonstrated that by being nice to Elisha and offering him a meal. We have reason to think she made it a standing invitation every time Elisha came to Shunem or passed through on his way elsewhere.

The woman wanted to do something more that would be nice for her friend Elisha. After talking with her husband, and apparently gaining his agreement, she used some of her wealth to build an addition to their home for Elisha to stay in. They added a room on the roof, making a second floor. They most likely added a separate staircase on the outside of the house for Elisha to have a private entrance. In the room the woman and her husband placed a bed, table, chair, and lamp for Elisha's comfort.

Their hospitality helped Elisha spread God's Word. Her "nice thing" was giving part of her home to someone else without expecting anything in return. It was a way she shared God's care with someone.

What ways can you share God's care for someone? Help your little ones know that they can share God's care, too, by simple things like giving a hug or helping out.

Scripture Reference:
2 Kings 4:8–11

Memory Verse:
Love is kind.
1 Corinthians 13:4

Teacher Tips

"Color Bingo" adapts the classic bingo game to provide children with frequent and real opportunity to do something nice for friends. Every play of the game presents an occasion for someone to share. The children will look forward to their opportunity, which is based on a random draw.

Each turn will also present an opportunity for you to revisit the story about Elisha's friend who was nice to him over and over again by sharing a room, bed, table, chair, lamp, and meals with Elisha.

In addition, this game provides the children with an opportunity to reinforce color recognition, sorting, and small motor skills for finger dexterity.

Get It Together

- ☐ Poster board
- ☐ Scissors
- ☐ Ruler
- ☐ Red, blue, green, yellow, orange, and purple markers
- ☐ Black permanent marker
- ☐ Red, blue, green, yellow, orange, and purple craft foam
- ☐ Paper
- ☐ Plastic bowl
- ☐ 7 small resealable bags
- ☐ Large resealable bag

How to Assemble

1. Cut poster board to make six 6" x 7" cards. Print "Bingo" across the top of each card. Draw lines dividing the remaining 6" x 6" area of each card into a 3" x 3" grid of 2" squares.

2. Color the nine 2" squares different colors: red, blue, green, yellow, orange, or purple so that touching squares are different colors. Duplicate colors as needed but no more than one set of three squares on any card may duplicate one color.

3. Cut each color of craft foam into 18 shapes slightly smaller than the 2" squares on the game cards for game markers. Separate all 18 pieces of each color into small resealable bags.

4. Print a color name (red, blue, green, yellow, orange, brown, or purple) on slips of paper with the corresponding color marker. Fold each so the color name is inside and collect all in a small resealable bag.

5. Collect completed Color Bingo game cards, bags of markers, bag of color name papers, and a plastic bowl in a large resealable bag labeled, "Color Bingo: color matching, sharing, finger dexterity."

How to Play

1. Open your game bag to give each child a "Color Bingo" card and a bag with one color of foam game markers in it.

2. Empty the folded papers with color names into the plastic bowl.

3. Draw out one slip from the bowl and call out the color.

4. The child with that color game markers places a marker on one square of matching color on his or her game card. The child with the color game markers that was called may be nice to others by giving the color markers to the other players so they may also put a marker on a corresponding colored square on their game cards.

5. Repeat steps 3 and 4 until a player has the correct color of game markers on three squares connected going across, down, or diagonally.

6. Have the players clear their game cards, return colored markers, and prepare to play again.

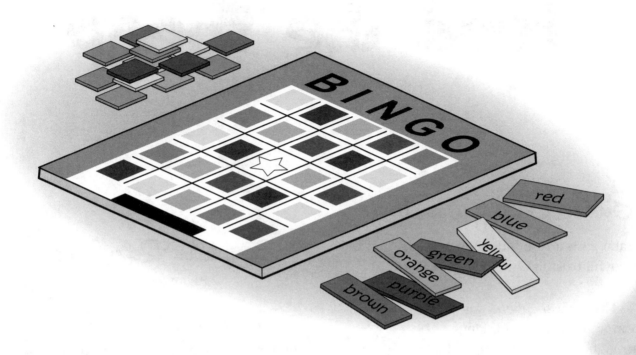

Game Wrap-up!

• **Friends do nice things for each other. That's what Elisha's friend did. What nice thing has a friend done for you?** *(Let the children tell their stories. Reinforce all the nice things friends have done for the children.)*

• **What nice things can you do for others?** *(share my toys, play with them, etc.)*

We do nice things for each other because that makes God happy. Let's ask Him to help us be nice to each other. Dear God, we want to do nice things for each other. Please help us think of ways to be nice and to show kindness to others. Show us what to say to make a friend happy. Give us the words to say that would brighten their day. We love You. In Jesus' name, amen.

Feed the Sheep

Bible Background

Psalm 23 is a resounding expression of joyful trust in our God who cares for us!

The term *shepherd* was a common metaphor for kings throughout the Near East including Israel. The writer, David, who became the King of Israel, acknowledged that the Lord is the true Shepherd-King.

The opening stanza is packed with the care David and all God's people enjoy: our needs are met (vs. 1) so we can rest secure having nourishment and well-being (vs. 2). Our spirits are alive (vs. 3a), as we follow our Shepherd on a path that is safe, morally upright, and prosperous (vs. 3b). Our Shepherd does His job to count, guide, rescue, and protect His sheep even when danger is present (vs. 4).

The second stanza, beginning at verse 5, addresses our Shepherd as one who makes us the honored guest at His victory banquet and in His home where we dwell forever under His shepherding care (vs. 6). In Bible times, it was tradition that honored guests received anointing upon arrival (Luke 7:46).

Because sheep depend on human care for survival, they completely trust in their shepherd. David equates God with being our Shepherd. What does it mean to say the Lord is *your* God?

Scripture Reference:
Psalm 23

Memory Verse:
The LORD has done great things for us.
Psalm 126:3

Teacher Tips

"Feed the Sheep" engages children in counting while moving objects. It pairs the cognitive process with physical activity in a way that teaches and reinforces the one-to-one relationship that must be understood for counting to be truly meaningful.

Preschoolers might say their numbers in order by rote memory but not be certain of the relationship between the numbers they say and the relative quantities each number represents.

This activity requires some fine motor skills. Be patient when children strive to work their fingers. Don't interfere or worry when the cereal gets crushed. Sheep aren't picky and neither are most preschoolers! Just dump out the crumbs and get more cereal pieces.

While children are counting and after the activity, connect the experience to God's promise to care for us from Psalm 23.

Get It Together

- ☐ Empty egg carton
- ☐ Scissors
- ☐ Black permanent marker
- ☐ 6 large white puff balls
- ☐ 12 small white puff balls
- ☐ Black felt
- ☐ Black puffy paint
- ☐ Craft glue
- ☐ Round oat cereal
- ☐ Medium resealable bag
- ☐ Large resealable bag

How to Assemble

1. Cut the bottom portion of an egg carton lengthwise to make two strips of six cups. Discard one strip of six cups.

2. Glue a large puff ball to the side of each of the six egg cups on the strip. These will be the bodies of six sheep at a feeding trough.

3. Glue a small puff ball to each large puff ball as a sheep's head positioned as if ready to eat out of each egg cup of the feeding trough.

4. Cut 12 small triangles of black felt and glue two as ears on the sides of each sheep's head.

5. Use black puffy paint to finish the eyes and nose on each sheep's head as if looking down into the egg cup.

6. Glue a small puff ball to the back side of each sheep's body for a tail.

7. Print numbers 1 through 6 on the inside of each cup under each sheep.

8. Collect oat cereal in the resealable bag.

9. Place the bag of cereal and sheep at the feeding trough in a large resealable bag labeled, "Feed the Sheep: counting, finger dexterity."

How to Play

1. Place your six sheep at the feeding trough and the bag of oat cereal in front of the children.

2. Point out the numbers on each feeding cup as you count the sheep with the children.

3. The first child playing counts aloud while filling one piece of oat cereal into the feeding cup for sheep #1 then two pieces of cereal in the cup for sheep #2 and so on through all six sheep at the feeding trough.

4. Empty the feeding trough and let the second child repeat from step 3.

5. Optional: Have the children give each sheep one piece of oat cereal at a time but no more than the number shown on the outside of each feeding cup.

6. Optional for children without allergies to the contents of oat cereal: After each sheep has been fed, child may check their work by removing pieces of oat cereal one at a time and eating each piece as they count.

7. Optional for older children: Have the children fill the feeding trough in step 3. Then ask each child to add 1 or 2 pieces of cereal at a time, counting on, to tell the new total in each feeding cup.

Game Wrap-up!

- **Who takes care of sheep?** *(A shepherd takes care of sheep.)*
- **Who takes care of you and me?** *(God does.)*

The shepherd watches over, cares for, and protects his sheep. God is always watching over you and me to take care of us and protect us. God takes care of you and me.

Dear God, thank You for taking care of us. We love You for watching over us to take care of us and protect us. In Jesus' name we pray, amen.

Escape to Egypt

Bible Background

God took care of Jesus, and working through Herod's paranoia about losing power, God fulfilled prophecies about the Messiah. Herod's threats to try to find and kill Jesus gave urgency to the angel's instructions and the escape to Egypt.

We also can see how God allowed the Magi to help care for and provide for Jesus. First, the Magi obeyed God's instructions to not return to Herod. Second, the Magis' gifts of gold, incense, and myrrh were valuable. Joseph likely sold or traded them for more essential food and shelter for the family in Egypt.

Scripture Reference:
Matthew 2:7–23

Memory Verse:
A Savior has been born.
Luke 2:11

The Magi were not kings, but most likely wealthy men who studied the stars. That is how they knew a King was born and found Him, but not at a stable with Jesus in a manger like the shepherds who saw Jesus after His birth. The Magi found Jesus at a home in Bethlehem, most likely rented by Joseph.

Herod was known for drastic measures to remove people he didn't like or trust. He ordered soldiers to kill family members and supposed friends he thought might usurp his power. We don't know how many boys under two years of age died. It probably was not many because Bethlehem was small—but the murders were brutal nevertheless.

Like the trip from Nazareth to Bethlehem before Jesus was born, this trip to Egypt would not have been easy. The departure was rushed and unplanned. Jesus was likely one or two years old, which was not an easy age for traveling.

How frightening the flight to Egypt must have been for Mary and Joseph! You may not be fleeing for your life, but you may have some situations that have left you feeling vulnerable. Just as God protected Jesus, He will also protect you. You can trust in God's protection in all areas of your life.

Teacher Tips

"Escape to Egypt" involves the children with the story in Matthew 2:7-23 by using their large motor muscles while reinforcing number recognition and sequence skills.

For the first few rounds of play it might be best to keep the carpet squares in easy and obvious sequences. You might also place the squares at distances that would be merely long steps for the children.

As your children advance and gain more experience, place the squares such that from number 2, for example, a child could easily jump to either 3 or 4, and then still be able to jump to the fifth square and then to safety in Egypt. Such arrangements will challenge and stretch their understanding of numbers.

After the children become proficient jumping through the sequence of carpet squares, have them stop at each square for you to retell the story in Matthew 2:7-23 or talk about it with them. For example, Bethlehem: Jesus was born in Bethlehem;

1: Magi came to visit Jesus; 2: They brought gifts to Jesus; 3: Herod didn't like Jesus and wanted to hurt Him; 4: The Magi went home but didn't tell Herod where Jesus was; 5: God sent an angel to tell Joseph and Mary to escape to Egypt; and 6: We are happy that God took care of Jesus.

Get It Together

- ☐ 7 carpet sample squares with short pile obtained free or at modest charge from carpet dealers
- ☐ Thick, black permanent marker
- ☐ Nonskid backing for carpet
- ☐ String
- ☐ Notepaper, tape, pen

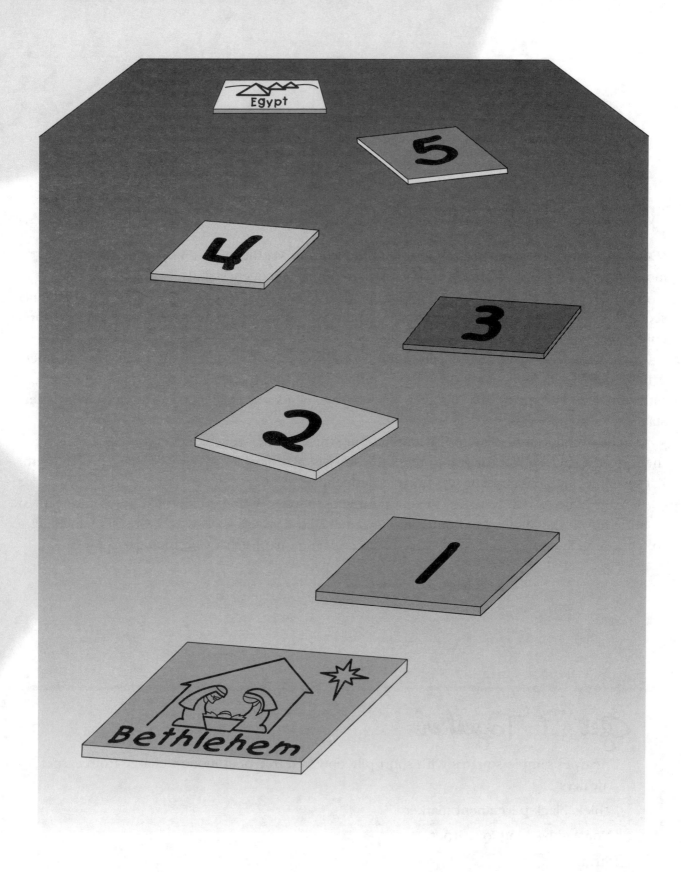

How to Assemble

1. Draw a manger and stable and print "Bethlehem" on one carpet square.

2. Draw pyramids and print "Egypt" on one square.

3. Number the remaining carpet squares 1 through 5.

4. Attach nonskid backing to each square.

5. Stack the carpet squares and tie string around them to keep them together.

6. Tape a notepaper to the string and label it, "Escape to Egypt: number recognition/sequence, story sequence, large motor jumping skill."

How to Play

1. Spread out carpet squares beginning with the Bethlehem square, then 1–5 in order, and Egypt at the end so children can jump from one square to another in sequence of the Bible story.

2. Children retrace the escape from Bethlehem to Egypt by jumping from one square to another in sequence.

3. Alter the arrangement of the squares to add challenge but still in a way that also allows the children to jump from square to square in sequence of the story. Let the children jump through the story again.

Game Wrap-up!

• **Who took care of Jesus?** (*God took care of Jesus.*)

• **God helped Mary and Joseph take Jesus to a safe place. Where did they go for safety?** (*They went to Egypt, away from Herod.*)

• **What can we do to show how happy we are that God took care of Jesus?** (*Children might suggest singing, jumping and shouting, and praying.*)

Dear God, thank You for taking care of Jesus. Thank You for taking care of us. In Jesus' name we pray, amen.

Build a Story

Bible Background

Stories develop pictures in our minds that help us remember a message. Jesus was a master storyteller presenting parables that used common knowledge and experiences to drive home spiritual truths.

Jesus' story of the wise and the foolish builders connected with His audience because most people built their own houses. There was no home construction trade as we know it today; but family members, friends, and neighbors would help one another. People also selected the location to build unless they were expanding or adding on to an existing dwelling. It was common knowledge to build on a solid foundation on higher ground. People knew how to find a solid foundation and did not build on the dry sandy creek beds that were subject to flooding or on sand dunes that would easily wash away.

Jesus said, "When a flood came . . ." not *if* a flood came. Whether we put Jesus' words into practice or not, we will all experience challenges in life. The difference is, those who learn about Jesus from His stories and practice what He teaches will weather the storms in life and experience the goodness of following Jesus. When you put your trust in God and follow His Word, your life is built on a strong foundation. It is strong enough to face any life storm that may come your way.

Scripture Reference:
Matthew 7:24–29; Luke 6:46–49

Memory Verse:
I am with you always.
Matthew 28:20

Teacher Tips

"Build a Story" creates opportunity for you to reinforce the truth that a life built on what we learn from Jesus is strong. It also helps establish an important prereading skill for recognizing the sequence in stories.

Complete stories have a beginning, middle, and end. To understand stories we need to be able to correctly sequence and remember these parts. Preschoolers can learn this skill by listening to a story and then doing an activity that helps them review the parts in sequence. Talking about the parts of a story is good but doing something with the parts while talking about them is better. We always learn more by getting physically involved.

Get It Together

- ☐ 5 empty 5" x 7" tissue boxes
- ☐ Newspaper
- ☐ White adhesive paper
- ☐ Black permanent marker
- ☐ Optional: wood- or brick-design, adhesive paper
- ☐ Large shopping bag

How to Assemble

1. Fill empty tissue boxes with crumpled newspaper.

2. Cover boxes with adhesive paper. Optional: Cover only one side with white and the rest with wood- or brick-design paper.

3. Draw the following stick figure pictures on one panel of each block:

> Picture 1: Two men hammering on two half-built houses. Dots (for sand) under one house and strong black lines under the other house (for rock).
>
> Picture 2: Completed house on sandy ground with smiling builder.
>
> Picture 3: Rain coming down and house in a shamble of lines with man sad and crying.
>
> Picture 4: Completed house on rock with happy man beside it.
>
> Picture 5: Rain coming down and house standing with man beside it smiling.

4. Optional: Copy the pictures from these two pages, enlarging as needed and glue or tape to one side of each box.

5. Collect your five story boxes into a shopping bag labeled, "Build a Story: story sequence, vocabulary development."

How to Play

1. Review Jesus' story of the wise and foolish builders and reinforce its lesson that doing what Jesus says is good for us.

2. Place the story blocks in random order in front of the children.

3. Ask a child or small group of children to stack the blocks so the pictures present the story in correct order from the bottom going up. Only if needed, hint about how any one picture block relates to the story and what happened before or after that part.

4. Once complete, let the children tell Jesus' story about the wise and foolish builders. Help as needed for accuracy. Then let the children knock the blocks down and repeat steps 3 and 4.

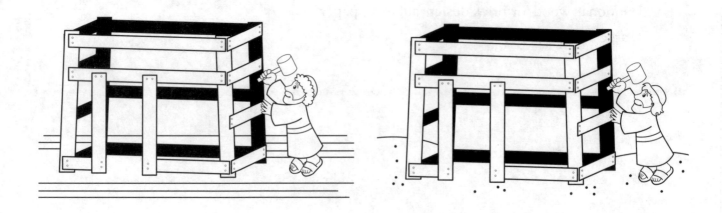

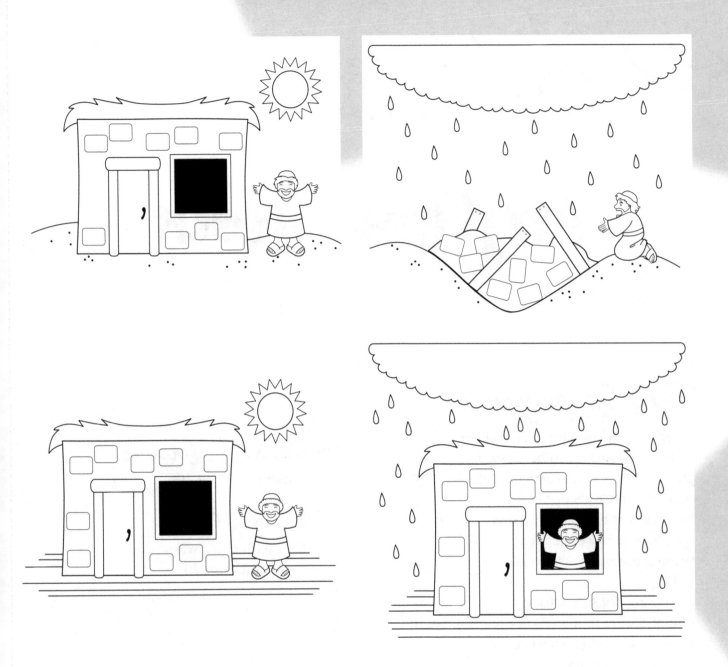

Game Wrap-up!

- **What is the strong house built on?** *(the rock)*
- **What happened to the house built on sand?** *(It fell down.)*

We learn about Jesus from His stories. He told a story about a wise man who built his house on rock so it would stay up during a storm. This story teaches us that when we do what Jesus says, we are wise like the man who built his house on the rock. Let's thank Jesus for helping us learn about Him from His stories.

Dear Jesus, thank You for telling stories that help us learn about You. Help us do what You say so we can be wise like the man who built his house on the rock. In Your name we pray, amen.

Anytime Jesus

Bible Background

Parents likely brought their children to Jesus voluntarily to be blessed. Often parents would bring a child to a rabbi near his or her first birthday. Rabbis gladly bestowed blessings because they truly wanted to impart that to all people.

We are not sure what the disciples were thinking! They realized that the custom of blessing would take a great deal of Jesus' time. They also may have been concerned for the weariness of their Master.

The parents were likely surprised by the disciples' reaction. The Gospel of Mark records that Jesus was indignant (Mark 10:14). Matthew and Luke show that Jesus definitely overruled the disciples before an opportunity was lost or people got the wrong idea about Jesus.

Jesus used this teachable moment to help the disciples and us understand that God does not turn away anyone—child or adult. Jesus always has time for us. It is how He shows His love and greatness. Help your students understand this concept by taking time to listen to them when they share something with you. Your interest in their lives will help convey that God always has time for them.

Scripture Reference:
Matthew 19:13–15

Memory Verse:
I am with you always.
Matthew 28:20

Teacher Tips

"Anytime Jesus" is a memory matching game that creates opportunities for children to build their short-term memory and reinforce concepts about time and daily activities. The children should also come away from the game with a clear understanding that Jesus has time for them during every part of their day.

The game cards you make ahead for this game will be prompts for talking with the children about the events of their day. Use the game to encourage the children to remember they can go to Jesus and talk with Him during all the times of their day. Jesus always has time for us.

Children use various clues to pair up matching cards. Clues might include location of the cards, shapes, and sizes. You can make your "Anytime Jesus" game more challenging by not duplicating any shapes or make it easier by making pairs of the activity picture cards in the same shape. If you use common shapes such as squares, triangles, and circles, the matching process will become much easier and give you materials for helping the children also develop experience with shapes.

Get It Together

- ☐ Poster board
- ☐ Glue sticks
- ☐ Scissors
- ☐ Magazines with pictures of daily activities that can be cut out
- ☐ Black marker
- ☐ Copy machine
- ☐ Clear self-adhesive paper or laminator
- ☐ Large resealable bag

How to Assemble

1. Cut at least eight pictures, roughly 4" x 4", from magazines that show various parts of a preschooler's day such as waking up, eating breakfast, playtime games, school-time activities, lunch, nap, bath, and bedtime. You may also draw these pictures or search the Internet for pictures to print.

2. Glue pictures on the poster board.

3. Print a word or two under each picture describing the time shown such as Time to Get Up, Time to Eat Breakfast, and so on.

4. Cut out each mounted picture.

5. Photocopy a duplicate of each picture and mount on similar-shaped poster board to make pairs of activity picture cards. To make the game more visually appealing, put stickers with the same image on the backs of each of the picture cards before laminating. Then all the cards will look the same, with color, when the cards are set up.

6. Cover all picture cards with clear self-adhesive paper or laminate.

7. Store the completed activity picture cards in a large resealable bag labeled, "Anytime Jesus: matching, time, short-term memory."

How to Play

1. Open your game bag and spread the pairs of game cards in front of the children.

2. Ask the children to collect the pairs of pictures and tell what they show. Reinforce how we can come to Jesus at each of the times shown and any other time.

3. Mix up the cards and lay them picture-side down.

4. The first player turns over one card and then turns over a second card attempting to turn up a matching pair. If the selected cards match, the child puts them in a pile and tells about the activity and time shown when Jesus has time for us. If the cards don't match, the child turns both cards picture-side down.

5. Additional players repeat step 4 until all pairs of activity picture cards have been matched.

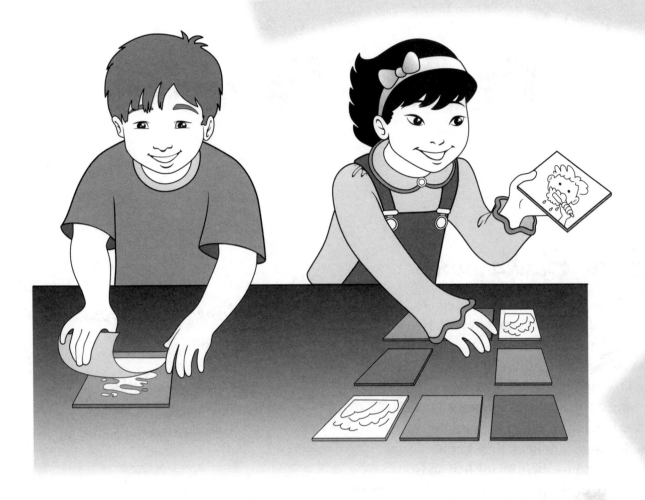

Game Wrap-up!

• **When can you talk to Jesus**? *(We can talk to Jesus anytime. Jesus always has time for us.)*

• **Is Jesus ever too busy to listen to us**? *(No, Jesus is never too busy to listen.)*

• **Does Jesus love you and think about you even when you're asleep? What about when you're playing?** *(Yes, Jesus never sleeps.)*

Dear Jesus, we are so happy that You always have time for us no matter what time it is or what we might be doing. You always listen to us. We love You. In Your name we pray, amen.

Praise Parade

Bible Background

Out of all the times Jesus entered Jerusalem, this time was different. He rode a donkey to publicly proclaim that He was the chosen Son of David—the one to sit on David's throne as the Messiah announced in Zechariah 9:9. When the people saw Jesus on a donkey, they knew what it meant—their Savior had arrived.

Plenty of people were present. Jesus entered Jerusalem during Passover—an annual festival celebrating deliverance out of Egypt. The population of Jerusalem swelled by as many as 1 million additional people who came to celebrate Passover.

Scripture Reference:
Matthew 21:1–11

Memory Verse:
Serve one another in love.
Galatians 5:13

The people shouted "Hosanna." It is a political term meaning "save us now." The people wanted Jesus to save them from the Romans as a political savior. That's not why Jesus came! He came to save us from the consequences of our sin. He is our eternal Savior.

The people spread their outer robes and branches from trees on the road just ahead of the donkey Jesus rode. This was another way to praise Jesus as royalty. John mentions palm branches—a symbol of victory which were prevalent around Jericho but not Jerusalem.

The people also shouted, "Blessed is he who comes in the name of the Lord!" This comes from Psalm 118:26, a psalm frequently read during Passover. It is interesting that another phrase the people shouted, "Glory to God [Hosanna] in the highest," was the same one the heavenly hosts sang as Jesus was born (Luke 2:14).

Think about Jesus and what He is to you. Is it time to cheer and shout? How can you show your enthusiasm for Jesus to the children in your class?

Teacher Tips

"Praise Parade" gets children engaged in celebrating Jesus while developing their large motor skills. Preschool children are still developing coordination for large motor arm movements. Considerable concentration is necessary to march and move the arms in a coordinated manner because both sides of the brain become engaged simultaneously.

Encourage the children to keep their streamer sticks up high so the streamers have plenty of room to fly and to prevent the sticks and streamers from getting entangled in their feet.

Point out the numbers on the ring and the corresponding number of dots on each stick. Read the numbers and count the dots with the children. Help the children count the sticks while pointing to them in numerical order. Remind the children to count the number of dots on their sticks to be sure they place the sticks into the corresponding numbered hole on the ring. All this activity with numbers will reinforce number recognition and sequencing—essential skills building readiness for math.

Get It Together

- [] 5 large paint stir sticks
- [] Permanent marker
- [] Ribbons in varying colors
- [] One 1 ½' diameter polystyrene foam ring

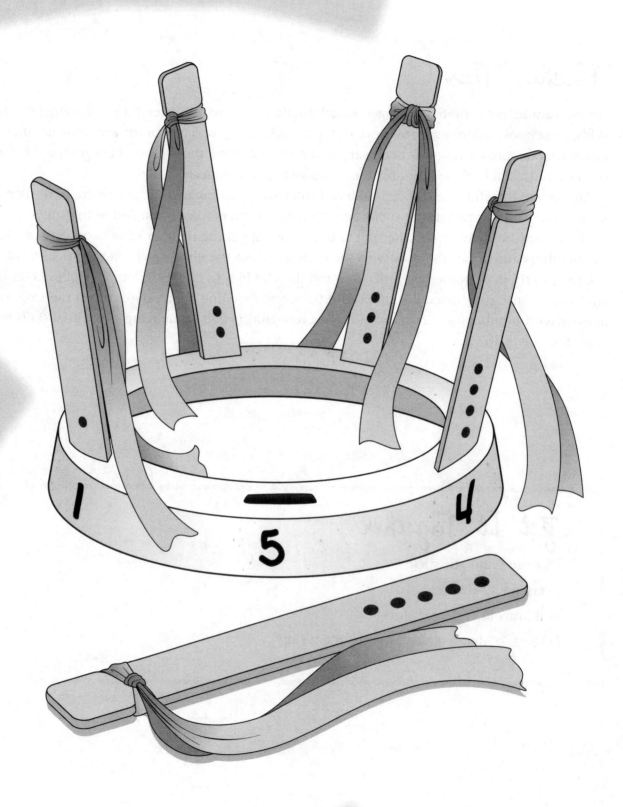

How to Assemble

1. Cut at least 25 ribbon streamers twice a long as your paint stirring sticks.

2. Tie at least five different colored ribbons to one end of each stick.

3. Push the opposite end of each stick into the foam ring about half the depth of the ring to make holes in the ring that will hold each stick upright and spaced evenly around the ring.

4. Number the holes in the ring 1 through 5 and mark a corresponding number of dots on each paint stick. For example: hole 1 has a stick with one dot on it.

How to Play

1. Put your "Praise Parade" ring where the child or children playing can easily reach it.

2. For one child playing: pick up number one stick.

3. March around the ring one time, waving the stick with streamers overhead and from side to side, shouting "Hosanna, praise Jesus!"

4. Return stick 1 and repeat step 3 for sticks 2 through 5.

5. For up to five children playing: each child selects a stick and then lines up in numerical order according to the numbered stick each has.

6. Children march around the ring and around the room waving streamers overhead shouting, "Hosanna, praise Jesus!" Children follow the motion and action of the leader waving streamers side-to-side, forward and backward, in a circle, and so on.

7. Children return their sticks to the praise ring in numerical order and the correct holes in the ring.

Game Wrap-up!

• **What good things do you get excited about?** *(new toys, birthday, school, playtime, favorite snack, etc.)*

• **What do you do when something really good happens?** *(shout, clap, smile, laugh, cheer, etc.)*

We can do all sorts of things when something good happens. Shouting and cheering are a couple of really good responses. One day, Jesus rode a donkey into Jerusalem. People on the side of the road shouted "Hosanna" to cheer for Jesus.

Today, Jesus still wants us to shout and cheer for Him. It is a way we can praise Him for loving us. Let's thank Jesus for loving us and then go on a praise parade to cheer for Him.

Dear Jesus, WE LOVE YOU! Yippee! We can't wait until we can see You and can give You a big hug. We love You. In Your name we pray, amen.

Fear Squish

Bible Background

The Sea of Galilee is a fresh-water lake in a deep basin surrounded by mountains. The region, and especially the lake area, is particularly susceptible to sudden and violent storms. Cool air from the Mediterranean Sea moves through mountain passes and clashes with warm humid air over the lake. The resulting atmospheric turbulence spawns wind and thunderstorms, especially in the evening hours.

Standard equipment on ships in Bible times included a cushion customarily stored under the coxswain's seat. Mark described Jesus resting during the storm until the disciples interrupted because they were afraid. Sleep indicates the full humanity of Jesus—He became exhausted, too. It may also show God's complete control of the situation even allowing the disciples to be fearful in order to drive home some lessons—Jesus is fully God and powerful over creation.

We all face fears. However, whether we are a preschooler who is scared of the dark or an adult scared of losing a job, we can rest assured during these "life storms." Jesus is still in control. When you face a "life storm," have faith; you don't need to be so scared. The Son of God is caring for you just as He cared for His disciples in the boat.

Scripture Reference:
Mark 4:35–41

Memory Verse:
The Lord is my helper.
Hebrews 13:6

Teacher Tips

"Fear Squish" creates opportunities for you to help preschoolers learn vocabulary to identify fears they may have but don't always know how to express. For every fear, you will have the opportunity to reinforce Jesus' presence with the children when they are afraid and that He cares when they're scared. It's a lesson that applies to people preschool-age and up!

Pushing golf tees into modeling clay and pulling them out will develop strength in little fingers. Prevent children from pushing tees so far into the clay that they will not be able to get a grip for removal.

Reinforce that because Jesus cares when we're scared, He can take away our fears and cover them up making them totally gone.

Get It Together

- ☐ Modeling clay, any color
- ☐ Multicolored golf tees
- ☐ Plastic container with lid
- ☐ Medium-size resealable plastic bag
- ☐ Large resealable plastic bag

How to Assemble

1. Press clay into the plastic container and cover with the lid.

2. Put tees in the medium resealable bag.

3. Collect the clay and golf tees in a large resealable bag labeled, "Fear Squish: vocabulary development, finger strength and dexterity."

How to Play

1. Remove the lid from the clay and set out the golf tees in front of the children.

2. Ask the first player to tell about something that he or she is afraid of, then take a tee and push it partway into the clay as you reinforce the fear that tee represents.

3. Let other players take turns repeating step 2.

4. Pass the clay with tees to the first player who pulls out a tee and then smoothes the clay to fill the hole the tee created. Reinforce that Jesus cares when we're scared and can remove our fears and cover them over.

5. Pass the clay to the other players who take turns repeating step 4 until all tees are removed.

Game Wrap-up!

- **When have you been afraid?** *(Let the children share their experiences. Listen and agree that their experiences are fearful.)*
- **What did you do?** *(Accept what the children say as reasonable responses.)*

Jesus is God so He knows when we are scared. He loves us and cares for us. Let's learn a prayer for when we are scared.

Dear Jesus, thank You for caring for us when we're scared. Sometimes we are afraid. Some of us are afraid of the dark, or afraid of people we don't know well. Help us to trust You and remember You are always there to help. We love You. In Your name we pray, amen.

Coin Lineup

Bible Background

The temple grounds included four areas: the Court of Gentiles for all people, the Court of Women for Jewish women and men, the Court of Men for Jewish men, and the Inner Court accessed only by priests. The Inner Court included the temple building with its Holy Place and Most Holy Place.

Jesus sat with His disciples in the Court of Women. Scattered around the area were 13 boxes for Jewish people to deposit money offerings. The top of each box was outfitted with a metal receptacle shaped like the bell of a trumpet or a funnel that directed coins down inside the box.

While not the intended purpose of the wide opening at the top, people would toss their offering or quickly drop it in. Of course the metal coins would ring and rattle in the metal receptacle while dropping down into the box. The larger the coin or the more coins tossed at once the greater the sound. It was easy to let people in the court hear your supposed generosity.

The widow gave two of the smallest coin in circulation. There would have been very little or no metal-to-metal sound, especially since she did not flaunt her gift by tossing it. Jesus knew exactly what she gave and how great a gift it was because of its relative comparison to what she kept for herself—nothing.

Giving is a way to worship God. It doesn't have to be a large amount of money—or even money at all. What do you have to give to God today?

Scripture Reference:
Mark 12:41–44

Memory Verse:
Worship the LORD.
Psalm 96:9

Teacher Tips

"Coin Lineup" engages children to use their large motor skills for moving around play coins, small motor skills for picking up coins, and cognitive skills for sorting and comparing the coins. Additional challenges are suggested in How to Play.

While playing with the children, talk with them about the day Jesus and His disciples watched people put various numbers of different size coins into the temple offering. We can all give to God. Explain that one woman gave only two of the smallest coins but Jesus said she gave the most of all because she gave all the money she had. Talk with the children about what they can give to God.

Get It Together

- ☐ 5 to 10 round lids or wooden disks (available at craft stores) of various sizes
- ☐ 2 equal-size, round lids or wooden disks that are the smallest of all disks
- ☐ Silver duct tape
- ☐ Black permanent marker
- ☐ White vinyl tablecloth
- ☐ Large resealable bag

How to Assemble

1. Cover lids or disks with silver duct tape.

2. Draw faces and other decorations on each covered lid or disk with black marker to make them look like ancient coins.

3. Place coins in random arrangement on the tablecloth.

4. Trace around each coin with the black marker.

5. Collect coins and tablecloth in a resealable bag labeled, "Coin Lineup: sorting, matching, compare/contrast, large motor coordination."

How to Play

1. Open the game bag, lay out the tablecloth, and put the coins in a pile in front of the children.

2. The first player matches each coin to its same-size outline on the tablecloth.

3. Collect coins into a pile and let second player repeat step 2.

4. Lineup variations: Have the children arrange the coins in a line from smallest to largest, then largest to smallest, or in a stack largest up to smallest.

5. Size comparisons: Select one coin and ask the children to collect all the coins that are larger. Repeat but ask the children to collect the coins that are smaller. Select one of the two smallest coins and ask a child to find an equal-size coin.

Game Wrap-up!

- **What can you give to Jesus?** *(coins, love, smiles, worship, etc.)*
- **Does Jesus only want us to give a lot or just what we have?** *(He wants us to give what we have.)*

Jesus and His friends who followed Him watched people bring their offering to God. They knew we can all give to God.

Some people gave many coins. Others gave big coins that could buy a lot of things. But one woman who didn't have much only gave two very little coins. We might think she did not give very much. But Jesus said she was more generous than all the others because she gave all the money she had.

Dear God, thank You that You accept whatever we can give to You. We love You. In Jesus' name, amen.

Birthday Count

Bible Background

Luke presents some world history before telling the account of Jesus' birth. Caesar Augustus, who ruled from 27 B.C. until his death in A.D. 14, ushered in the golden age of Roman culture. He ordered a census to strengthen military conscription and taxation. Jews were exempt from military service.

Scripture Reference:
Luke 2:1–7

Memory Verse:
A Savior has been born.
Luke 2:11

Joseph and Mary traveled from Nazareth to Bethlehem for the census. Both were required to report in their ancestral town which was Bethlehem, King David's birthplace. Joseph and Mary simply complied with the Roman law. God used the census decree of Augustus to fulfill the prophecy of Micah 5:2 regarding the birthplace of the Messiah.

We can well imagine Mary was glad to give birth in Bethlehem, even though in the most humble of settings, if for no other reason than to not have to make the return trip to Nazareth while even more pregnant.

Since David's family was so large, and other ancestral families originated from Bethlehem, the village was very crowded with men, women, youth, and children. Every private home was likely full of family guests. With no room in the inn, which was more like a first-come, first-served hostel open to the public, the pregnant couple retreated to a stable where occupants of the inn could put their animals. The stable was probably a cave. A manger is a rough wooden box for livestock feed.

It's amazing how God worked to fulfill messianic prophecies! In these humble beginnings, we can truly rejoice that Jesus is born.

Teacher Tips

"Birthday Count" engages one child or a small group of children with a teacher to do what the Romans did around Jesus' birthday—count the people! Through the activity the children will have fun while building counting skills, comprehension of the quantitative value of numbers, ability to identify pattern and sequence in numbers, and manual dexterity from manipulating the craft-foam people.

Watch the children as they study the cookie-cutter people and group them. Ask the children why they put certain colors or sizes of people where they do.

It is fine to point to the game pieces but also use words such as *first, second, repeat, pattern, sequence, small, medium,* and *large* in your conversation to help the children learn the vocabulary of sorting and sequencing. Let the children tell you the similarities and the differences that determine various sequences they create.

Reinforce the importance of Jesus coming, and that we are glad He was born.

Get It Together

☐ Craft foam in at least 3 different colors

☐ Small, medium, and large gingerbread-man cookie cutters

☐ Scissors

☐ Permanent marker

☐ Large resealable bag

How to Assemble

1. Trace cookie cutters onto craft foam.

2. Cut several small, medium, and large gingerbread-man shapes from each color of craft foam to make people.

3. Optional: Alter the cookie-cutter shape to make girls as well as boys.

4. Collect your cookie-cutter people into the bag and label it, "Birthday Count: counting, sorting, pattern sequence, finger dexterity."

How to Play

1. Open your game bag and randomly spread the craft-foam people in front of the children.

2. Ask the child or small group of children playing to count all the people. It is OK to move the people to help with counting.

3. Ask those playing to sort the people according to color making separate piles for each color.

4. Sort into piles of same sizes.

5. Place cookie-cutter people in a sequence of sizes (e.g., small, medium, large, small) and ask the children to continue the pattern you began. Repeat with alternative size patterns.

6. Put down a sequence of colors (e.g., red, blue, green) and ask the children to continue the pattern you began. Repeat with alternative and more complex color patterns.

7. For maximum challenge, put down a pattern sequence using size and color (e.g., small red, medium blue, large green, small red). Talk with the children about the sizes, colors, and pattern to help them repeat the sequence.

Game Wrap-up!

- **What do you do on your birthday?** *(eat cake, have a party, open presents, etc.)*
- **Are you glad that Jesus is born? Why?** *(yes, because He came to save me, He came to be our Friend)*
- **How do you celebrate Jesus' birthday?** *(have presents, have a party, sing to Him, etc.)*

Jesus was born in a stable for animals. Mary put baby Jesus in a manger—a wooden box that usually had food for the animals. Mary and Joseph were glad that Jesus was born. We are also glad that Jesus is born. Let's thank God for sending Jesus.

Dear God, thank You for sending Jesus to be born as a baby. We are glad Jesus is born. We love You! In Jesus' name we pray, amen.

Shape Hunt

Bible Background

Jesus was nice to everyone, including the social outcasts. In fact, He looked for the social outcasts so He could show them His love. In Jesus' day, the outcasts included tax collectors and prostitutes. It is obvious why prostitutes were hated. Tax collectors were hated because they worked for the Romans. Association with the Romans was the problem. It didn't help that tax collectors usually collected too much tax and kept the extra.

Luke 15:1-7 records Jesus speaking to the Pharisees, but of course others gathered around could also hear. The Pharisees were the religious leaders. They did not like sinners such as tax collectors and prostitutes and actually took measures to avoid such people.

Jesus told the Pharisees about a shepherd who left 99 sheep in the open to go find and bring back one lost sheep. The story had a familiar theme because shepherding was well known. Any good shepherd would go find a lost sheep, and everyone also knew the shepherd would know which sheep was lost. The one lost sheep emphasizes that every sheep is important to the shepherd, and likewise each of us to God. The 99 left behind in the open does not have any spiritual or shepherding significance. Seeking the lost is the key—whether it is one or many. That's why sinners were around Jesus—He looked for and found them. Jesus wanted the Pharisees to go look for people who were lost too.

Jesus knows you better than the shepherd knew the lost sheep. He loves you even more. He knows when you're happy and when you're lonely; and if you are feeling lost, He cares for you then, too. He'll come to find you to bring you to safety.

Scripture Reference:
Luke 15:1-7

Memory Verse:
Nothing is impossible with God.
Luke 1:37

Teacher Tips

"Shape Hunt" is based on the fact that good shepherds know their sheep and go find any that are lost. The activity provides opportunity for you to reinforce how Jesus cares when we are lost.

Large motor skills, dexterity, and one-to-one counting are developed in this activity. The "sheep" are tossed into the cup corrals, one sheep for each cup. Children can count each sheep as they toss them. If they miss, the lost sheep will need to be "found" again.

Preschoolers may fear getting lost. This game allows you to naturally ask about this possible fear and continue with further conversation. Use these opportunities to reassure the children that Jesus knows and cares when they are lost and might use parents, relatives, teachers, and others to be sure they are safe.

Get It Together

- ☐ 6 ping-pong balls
- ☐ White craft paint
- ☐ Hole punch
- ☐ Enough scrap yarn to tie cups together
- ☐ Artist's paintbrush
- ☐ Black permanent marker
- ☐ 6 large plastic cups
- ☐ Knife
- ☐ Scissors
- ☐ Medium resealable bag

How to Assemble

1. Paint ping-pong balls white to cover the black lettering. Set aside to dry.

2. With one hand holding around the bottom of the cup gently push a hole at the top of the cup with a knife. Make holes wherever the cups are connected.

3. Tie cups together through holes with 3-inch yarn. Cut off extra yarn.

4. After ping-pong balls have dried, use the marker to make each ball into a sheep by drawing legs, a fluffy tail, and a face. Curly wool can be drawn using small spiral shapes along the "back" of the sheep.

5. Collect your sheep and cup corral into the bag and label it, "Shape Hunt: large motor skills, dexterity, one-to-one counting."

How to Play

1. Toss one ball sheep into one cup. Continue until each cup has one sheep.

2. Distance from the cups depends on the individual child's skill. They will need to "find" each lost sheep when it misses the cup and rolls away.

3. Counting the sheep can take place before, during, or after they are thrown.

4. As the child chases down "missing" sheep, an adult may emphasize how the shepherd did the same thing.

Game Wrap-up!

- The shepherd in our story hunted for something that was lost. What was it? *(sheep)*
- Have you ever been lost in a store? What happened?
- Did you worry that no one would notice you were gone? Why or why not?

Let's thank Jesus for caring about us when we're lost.

Dear Jesus, thank You that You care about us. Please help us to remember that we can trust You to help us when we get lost. Thank You that there is no place that You won't be able to see us and give us help. We love You. In Your name, amen.

Jesus cares if we're lost. If you ever get separated from the adults you were with, stay in one place, ask a person in a uniform for help, and pray to Jesus to help you.

Thanks!

Bible Background

It may be that Luke included the story of the 10 lepers in his Gospel account because of his professional interest in health and medicine. Luke was a physician and presented Jesus as the Great Physician more than the other Gospel writers.

Leprosy is a contagious disease that lives in the nervous system and spreads through open sores. It is perhaps not so infectious to warrant the extreme isolation imposed upon lepers in biblical times. Leprosy appears as small discolored spots on the skin that continue growing into tumors that do not heal. Lepers wrapped themselves almost like mummies to keep the open sores from tissue infections that, if not resolved, could lead to amputations and sometimes death. Since leprosy attacks the nervous system, victims lose feeling in their hands and feet further complicating the risks. In biblical times, lepers could hardly get medical treatment because they were isolated and usually poor.

In Bible times lepers were declared ceremonially unclean. To be allowed back into society, the priest would have to declare the leper clean again. The laws were extensive (Lev. 13:1-46; 14:1-32).

Jesus cared for all 10 lepers. All were cured and undoubtedly re-entered society. The one who was thankful was also faithful and thus received a second miraculous gift far more powerful and important than a physical cure—salvation. "Your faith has made you well" may also be rendered "your faith has saved you."

How does Jesus care for you today? How do you respond to Him—with thankfulness or do you just get on with everyday life?

Scripture Reference:
Luke 17:11-19

Memory Verse:
The Lord is my helper.
Hebrews 13:6

Teacher Tips

"Thanks!" is an instructive adaptation of the familiar Duck, Duck, Goose that gets your children using their large motor muscles to burn some energy while also building consistent expression of gratitude.

Preschoolers may not naturally be considerate or grateful. But these qualities are easily taught. You can incorporate simple things such as saying "please" and "thank you" when appropriate in your classroom. You can demonstrate thankfulness whenever an opportunity arises such as when one child helps another or when someone hands you a Bible or even when the weather is nice. Young children will model what they see in you.

Get It Together

☐ none needed

How to Assemble

No assembly required.

How to Play

1. Have the children sit in a circle on the floor.

2. Select one child to be the thankful leper.

3. Have that child walk around the outside of the circle tapping children one at a time on their heads while saying a number from one to nine until tapping one child and saying, "Thankful."

4. Then the "Thankful" child gets up and chases the one who was doing the tapping around the circle until that child reaches the open space in the circle. That child sits in the open space. The one who was chasing says, "Thank you," then takes a turn doing step 3, and the game continues through step 4.

5. Play until everyone in the circle has had a turn to be tapped, "Thankful."

6. Optional: Play in the manner described above, only the child tapped as "Thankful" must say something he or she is thankful for such as the sunshine, a friend, a parent, etc.

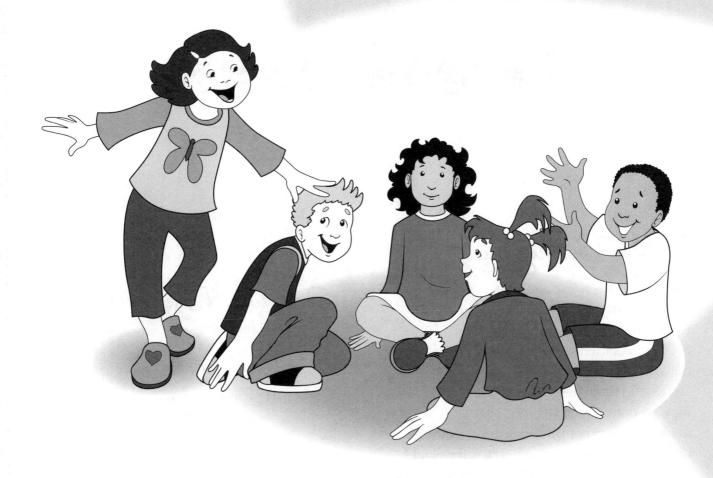

Game Wrap-up!

- **What are you thankful for?** (*Let the children talk. Acknowledge the value and importance of everything they mention.*)
- **Why can we be thankful?** (*Because Jesus cares, we can be thankful.*)

One of the sick men thanked God for making him well. God cares for each of us, too. We can thank God for that!

Dear God, thank You, thank You! You cared for the 10 sick men. You care for us. Thank You! We love You. In Jesus' name, amen.

Friend Jesus

Bible Background

Zacchaeus was a Jew and a tax collector. His job caused his neighbors in Jericho to hate him. No one wanted to be Zacchaeus's friend. They also rejected him from the local synagogue since his tax work put him in contact with Gentiles. That made him ceremonially unclean. Zacchaeus was rich—something folks would not have minded if he had gotten there honestly. But he collected too much tax like most tax collectors and kept the extra for himself.

Scripture Reference:
Luke 19:1–10

Memory Verse:
He cares for you.
1 Peter 5:7

It's no wonder people wouldn't let Zacchaeus step in front of them to get a glimpse of Jesus coming down the road. But Zacchaeus was resourceful, climbing into a sycamore tree and above the crowds. These trees grew to be 30 to 40 feet tall. That's where Jesus saw Zacchaeus.

People could hear Jesus tell Zacchaeus that He wanted to stay at his house. Jesus wanted to be with Zacchaeus because Zacchaeus was important to Jesus, just like everyone else. It wasn't because Zacchaeus was rich. Jesus is a friend to everyone.

Zacchaeus responded to Jesus' friendship receiving salvation, giving to the poor, and paying back four times the extra amount he took from people. This faith in action showed he was truly a son of Abraham (Rom. 4:12).

Jesus offers salvation to you, too. Have you accepted His friendship?

Teacher Tips

The "Friend Jesus" game allows the children to develop hand-eye coordination while kids gain experience with numbers, size relationships, colors, and magnets.

Children manipulate the heart-shaped pieces you make from craft foam with securely attached magnets to attract and move gingerbread-style people. The game pieces and activity options present a great context for conversation about numbers, sizes, colors, magnets, and especially how Jesus attracts people because He is a friend to everyone.

Lead the children in play with you or friends using magnetized hearts and working together to collect people according to number sequence, as similar or different sizes, or as color matches.

For more advanced children you can add backward number sequences or more challenging pattern sequences using colors. All through the play you can talk about how Jesus is a friend to everyone. He cares for all of us because everyone is important to Jesus.

Get It Together

☐ 2 flat craft magnets strong enough to attract a jumbo-size paper clip through a layer of craft foam

☐ 10 jumbo-size paper clips

☐ Craft foam, at least 5 different colors

☐ Scissors

☐ Craft glue

☐ Black permanent marker

☐ Large resealable bag

How to Assemble

1. Cut at least 10 gingerbread-style people out of craft foam to have at least two people from each of five colors and at least pairs that are 2" tall, 3" tall, and so on up to 6" tall.

2. Clearly number the top/front side of the gingerbread-style figures from 1–9. Draw faces, hands, and clothing on each one.

3. Glue a paper clip to the back of each of the people.

4. Cut two heart shapes about 6" tall and wide from craft foam. Print "Jesus" on one heart and "Jesus is a friend to everyone" on the other heart. Decorate the hearts as desired.

5. Glue a magnet to the back of each heart.

6. Collect the completed game pieces in a large resealable bag and label, "Friend Jesus: number sequence, size comparison, color matching, hand-eye coordination, large motor skill, experience with magnets."

How to Play

1. Randomly spread the people with the face/number side up. Point out that each person has a metal paper clip on the back. Talk about the different colors, sizes, and numbers.

2. Distribute one heart to a child who will play the game. Point out the magnet on the back and what the heart says on the front.

3. Explain that the heart will attract the people because of the magnet on the heart and the paperclips on the people. Reinforce the fact that Jesus is a friend who attracts everyone.

4. The child who plays manipulates the heart to pick up people in numeric order starting with 1. Talk about the numbers and help only as needed.

5. Celebrate that everyone is a friend of Jesus.

6. Redistribute the people.

7. Pass the heart to the next child who plays.

8. Repeat step 4 with another player. Reinforce that Jesus is a friend to everyone.

9. Optional: Add variations for one player using one heart to collect people into groups by colors, matching sizes, or arranging in size from smallest to largest.

10. Cooperative Extension: Have two players each use a heart and work together taking turns to accomplish a shared task such as collecting and arranging the people in numerical order or color patterns.

Game Wrap-up!

- **Who are your friends?** *(Allow children to name friends.)*
- **Who are some different people we have for friends?** *(mommy, daddy, dog, cat, imaginary friends, cousins, etc.)*
- **We also can share friends. Do you have some friends you share?** *(Answers will vary.)*

But all of us have Jesus for a friend. Jesus is (child's name) **friend and** (repeat naming each child one at a time) **friend and my friend. Jesus is a friend to everyone. Even when we might think no one else is our friend, Jesus is always our friend because He is a friend of everyone. Let's thank Jesus for being our friend.**

Dear Jesus, thank You for being our friend. Thank You that You are (say each child's name) **friend and that You do everything that a good friend would do for us. Thanks, friend Jesus! We love You. In Your name we pray, amen.**

Jesus is a friend to everyone!

Scared, Mad, Sad, Glad

Bible Background

Jesus was going to Judea and decided to walk on the Samaritan side of the Jordan River. Most Jews would not go on that side of the river because they looked down on the Samaritans and wanted nothing to do with them.

About noon ("the sixth hour") and the hottest part of the day, Jesus stopped to rest at a well. It was a bit unusual that a woman came to fill her water jug when it was so hot. Most people would go to the well in the morning when the temperature was more comfortable. Undoubtedly, the woman wanted to avoid people. The fact that Jesus was already at the well didn't bother the woman because she knew He was not from her town.

Jesus didn't have a jug or a cup to get water from the well so He asked the woman to draw Him some water. By His expression, she immediately knew He was a Jew and told Jesus that He should not talk to her. Jesus continued the conversation. Soon the woman discovered that Jesus knew everything about her—even the things she had done that were wrong. Jesus knew this because He knows who we are. Through more conversation, the woman heard Jesus tell her that He was the Messiah.

Jesus cares for you. He knows the good and the bad things about you—and still loves you. What great love He has for you!

Scripture Reference:
John 4:4-26

Memory Verse:
He cares for you.
1 Peter 5:7

Teacher Tips

"Scared, Mad, Sad, Glad" teaches the children to understand a few common emotions that all people experience and to connect facial expressions with those feelings. Show the appropriate face plate you made for this game as you talk with the children about what it means to feel scared, mad, sad, and glad. Show the children how each of the face plates shows these emotions.

Game play provides opportunities for children to make decisions, while developing skills for sorting and organizing objects. Since the children must move game pieces to play they will also gain finger dexterity and fine motor skills along the way.

The game provides plenty of opportunity to talk with the children about what makes them feel scared, mad, sad, or glad. Feel free to include additional emotions as well as the emotions the woman at the well might have felt. Your conversations will be excellent opportunities to learn about your class, help the children understand and accept their emotions, and to develop their language skills.

Get It Together

- ☐ 4 sturdy 10" paper plates
- ☐ Black permanent marker
- ☐ Glue stick
- ☐ Craft glue
- ☐ 1 poster board
- ☐ Scissors
- ☐ Magazines and newspapers with pictures of people who are scared, mad, sad, or glad
- ☐ Yarn and chenille wires
- ☐ Clear adhesive paper or laminator
- ☐ Resealable bag or box

How to Assemble

1. Draw a scared face on one plate. Make mad, sad, and glad faces on the other plates to complete four plates with faces showing different emotions.

2. Cut and then glue yarn for hair. Push chenille wires through the plate then shape for crazy hairstyles to finish your faces on plates.

3. Cut out several magazine and newspaper pictures of people expressing scared, mad, sad, and glad emotions. Optional: Include additional emotions.

4. Glue pictures of people to poster board.

5. Cut the poster board leaving a 1/3-inch border around each picture for picture cards.

6. Optional: Cover one or both sides of each picture card with clear adhesive paper or laminate.

7. Store all pieces in a resealable bag or box labeled, "Scared, Mad, Sad, Glad: sorting, matching, feeling identification/language skills, finger dexterity."

How to Play

1. Open your game bag or box and arrange the four plates face up and the picture cards face down in front of the children.

2. The first one playing picks up one picture card, turns it over to look at it to tell the emotion shown. The player may ask for help to tell the emotion.

3. Player decides which of the four face plates shows an emotion most similar and sorts the picture card placing it face up by the face plate.

4. Second player repeats steps 2 and 3.

5. Continue play taking turns until all picture cards have been sorted to the face plate most similar to each.

6. Return all picture cards face down and play again.

7. Extension: Ask players to tell about a time when they felt the same emotion shown on the picture card he or she drew after sorting in Step 3.

Game Wrap-up!

• **How can you know when someone is happy? Sad? Angry?** *(by how they look, they are smiling or frowning or scowling, etc.)*

• **Show me a happy face; a sad face; a scared face.**

• **What does Jesus know about you?** *(Answers will vary.)*

We can know about people and their feelings or emotions by looking at their faces. Tears, smiles, angry words, and frowns that look like upside-down smiles, let others know our feelings.

Jesus knows our feelings, too. In fact, He knows everything about us. When we are glad, scared, mad, or sad, Jesus knows. That's something we can be glad about and thank Him for!

Please fold your hands and close your eyes to pray with me. Dear Jesus, You know who I am. You know each one of us. Thank You for knowing who we are. We love You. In Your name we pray, amen.

Lunch for a Bunch

Bible Background

This story appears in all four Gospels. The other accounts (Matt. 14:13-21; Mark 6:32-44; Luke 9:10-17) indicate Jesus and His disciples retreated by boat to a quiet place on the shore of the Sea of Galilee, probably near Bethsaida. Because of His popularity and healing miracles, a large crowd followed Jesus. Undoubtedly there were women and children in addition to the 5,000 men. All wanted to hear Jesus teach and to observe His miracles.

Jesus asked Philip where to buy bread to feed the people. Philip was from the region so he might know where to find food and lots of it. But that was not Jesus' intention. Philip's response that "Eight months' wages would not be enough for each one to have a bite!" was no concern to Jesus. He wanted to show what God was like by demonstrating that He supplies our needs and can do it with very little. Jesus can do a lot with a little! "Nothing is impossible with God" (Luke 1:37).

The disciples found a boy with a typical lunch—five barley loaves and two fish. Apart from Jesus, it would have been enough for the boy. Jesus thanked His Father in heaven for the bread and then the fish, and then miraculously shared bread and fish with everyone. All the people ate until they were full. Then the disciples collected 12 baskets of food. Jesus can do a lot with a little.

Scripture Reference:
John 6:1-14

Memory Verse:
Nothing is impossible with God.
Luke 1:37

Teacher Tips

"Lunch for a Bunch" engages the children to understand the quantity each number represents while having fun counting, sorting, and then throwing beanbags at a target. The game activity generates plenty of opportunity to talk with the children about the little lunch Jesus used to feed a lot.

Skills emerge at different ages in children. While many of your children might be the same age, some might be more skilled in counting than in throwing, for example. Adapt your use of the game accordingly. Help individual children count or ask them to do it together as needed. Move the basket closer or farther according to the large motor skills of each child.

Allergy alert: Use any bean but fava beans, as rare but serious allergies have been noted by some to them. If you have a child with a severe nut allergy, you should not expose him or her to any kind of beans, as children who are allergic to nuts may also be highly allergic to legumes as well.

Note: Beans can be a choking hazard and some small children have been known to try to put beans in their ears or nose, so supervision is a must.

Get It Together

☐ Pair of clean white tube socks

☐ 5 nylon knee-high socks

☐ Colored permanent markers

☐ 2' yarn or string

☐ 1 basket, roughly 8" x 10"

☐ 4 pounds of pinto beans

☐ Index cards

☐ Measuring cup

☐ Storage box with resealable lid

How to Assemble

1. Put 1 cup of beans in each tube sock. *(Use any bean but fava beans, as rare but serious allergies have been noted by some to them. If you have a child with a severe nut allergy, you should not expose him or her to any kind of beans, as children who are allergic to nuts may also be highly allergic to legumes as well. Note: Beans can be a choking hazard and some small children have been known to try to put beans in their ears or nose, so supervision is a must.)*

2. Tie yarn or string around each sock to contain the beans loosely in the toe-end of each sock. Leave the rest of each sock as a tail. Tie together a small pucker of cloth at the toe end of each sock.

3. Use markers to draw a fish's mouth on the small pucker of cloth, then eyes, gills, fins, and scales to complete each as a beanbag fish.

4. Put 1 cup of beans into each nylon sock then tie off the open end of each to make five beanbags about 6" long. Cut off any extra nylon to complete five bread-loaf beanbags.

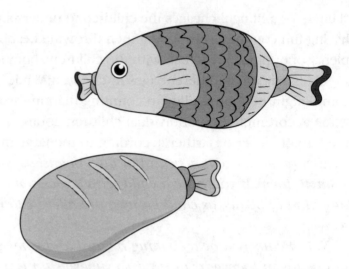

5. Write 5, 2, or 7 on each index card.

6. Collect your fish and loaf beanbags, basket, and cards into a storage box with a resealable lid labeled, "Lunch for a Bunch: large motor throwing skill, sorting, counting, number recognition, value."

How to Play

1. Unpack the game from the box, placing the basket a distance from the child with the seven beanbags and numbered cards in front of the children.

2. Ask the first child or small group of children playing to count all the beanbags and place them on top of the corresponding numbered card. Help as needed.

3. Have the children sort the two different types of beanbags to piles on top of the other two corresponding numbered cards. Talk about the differences between the beanbags and what they represent (five loaves of bread and two fish).

4. Let the children throw the bread beanbags into the basket one at a time.

5. Have the children toss the fish beanbags into the basket.

6. Retrieve any bread or fish beanbags that did not go into the basket so the children may throw them again.

7. Together, count the bread and fish beanbags in the basket. Remind the children that Jesus fed more than 5,000 people with five loaves of bread and two fish. Jesus can do a lot with a little.

8. Collect the bread and fish beanbags and repeat the game from step 2.

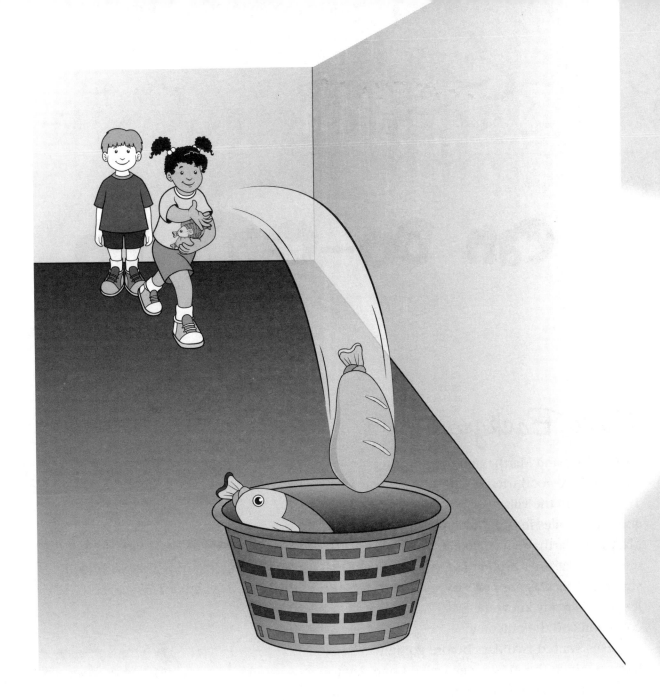

Game Wrap-up!

- **Who gave Jesus his lunch to share?** *(the little boy)*
- **Jesus did a lot with a little. How many fish did the boy give?** *(two)* **How many loaves?** *(five)*
- **What can you share with Jesus?** *(Answers will vary.)*

Jesus can do a lot with a little. A boy gave his lunch of two fish and five loaves of bread to Jesus, and Jesus fed more than 5,000 people. Everyone ate all they wanted, and still food was left over. We might think that what we have to give Jesus is not very big. That doesn't matter to Jesus because He can do a lot with a little. He can do a lot with whatever we give Him.

Dear Jesus, thank You for doing a lot with a little. Please do a lot with everything we give You. In Your name we pray, amen.

Can Do—Can't Do

Bible Background

Sisters Mary and Martha, and their brother Lazarus were good friends with Jesus. They lived in the village of Bethany about two miles from Jerusalem. Mary and Martha sent someone to tell Jesus that their brother Lazarus was sick. This was not news to Jesus. He already knew the condition and the outcome.

Jesus waited two days before going to Lazarus. Since the messenger walked one day to get to Jesus, then Jesus waited two, and then He spent another day walking to Bethany, Jesus arrived four days after Lazarus died. Everyone knew Lazarus was really dead by this time! People believed that a dead person's spirit, or life, could return within three days of death. By the fourth day one was really dead.

Everyone who knew Lazarus was sad, including Jesus. But Jesus knew Lazarus died for a purpose—to show people God can do anything. Because of previous experiences, many already believed Jesus could have healed Lazarus if Jesus had arrived when Lazarus was alive. They did not know He could raise Lazarus from the dead.

Mary and Martha initially objected to Jesus' instruction to move the stone away from the tomb. Their apparent willingness, based on Jesus' encouragement for belief, indicates a shift to at least anticipating what God might do and perhaps a shift to bold faith that He can do anything. The miracle of Lazarus's resurrection produced faith in some who observed it and others who heard later. Faith grows in all who rightly understand God's actions.

Is there something in your life that seems overwhelming? Trust in God—nothing is impossible with Him.

Scripture Reference:
John 11:1-45

Memory Verse:
Nothing is impossible with God.
Luke 1:37

Teacher Tips

"Can Do—Can't Do" lets children use their imaginations while play-acting to reinforce the truth that God can do anything while also developing decision-making skills and large motor throwing talent.

You can increase the decision-making opportunities by working to obtain a good diversity of pictures that show actions the children can and can't do. Every child's turn in this game will be an opportunity to reinforce the truth that there are things we can do, but there are some things only God can do because He can do anything.

During play, children may overestimate their abilities. If that happens, suggest that the activity shown might be something they can do with help or will be able to do when they become older. Allow the children freedom to change decisions. You might help children admit they need help by telling about a time you misjudged what you could do and the disastrous consequences if humorous or at least not harmful. We all need to learn that God can do anything, and we can't!

Get It Together

- ☐ 1 sheet of poster board
- ☐ Red and black markers
- ☐ Magazines with pictures of various people doing things
- ☐ Scissors
- ☐ Glue stick
- ☐ 2 small buckets or large plastic bowls
- ☐ 1 skein of multicolored yarn
- ☐ Resealable bag
- ☐ Optional: Clear adhesive paper or laminator
- ☐ Storage box with resealable lid

How to Assemble

1. Cut out at least 10 magazine pictures of various ages of people doing different activities such as jumping, hopping, dancing, running, drinking from a cup, playing a game, driving a car, painting a house, lifting heavy objects, and so on. Some pictures should show activities too hard for a child. Optional: Draw pictures suggested above.

2. Glue your pictures to poster board and then trim the poster board around each picture. Optional: Cover each picture with clear adhesive or laminate. Store completed pictures in a resealable bag.

3. Print "I can" in black on one bucket or bowl and "I can't" in red on the other bucket or bowl.

4. Wind yarn loosely around four fingers, about 30 to 40 times and pinch loops together in the middle.

5. Tie yarn around the middle.

6. Cut loops and fluff the ends of yarn to make a ball.

7. Repeat steps 4 through 6 to make 10 fluff balls.

8. Collect the buckets or bowls, picture cards, and yarn balls into a storage box labeled, "Can Do—Can't Do: sorting, large motor throwing skills, hand-eye coordination."

How to Play

1. Open the game box and spread picture cards picture side down in front of the children. Read each bucket or bowl and place both at appropriate throwing distances from the children.

2. Have the first player select a picture card and look at it to decide if the picture shows something he or she can or can't do.

3. If the child can do the activity on his own, then he acts it out and throws a fluff ball into the "I can" bucket or bowl. If he can't do the activity on his own, then he only throws a fluff ball into the "I can't" bucket or bowl. When children miss, they can retrieve the ball and try again or toss a second ball.

4. Repeat steps 2 and 3 with another player until all have had a turn. Replace cards and retrieve balls as needed.

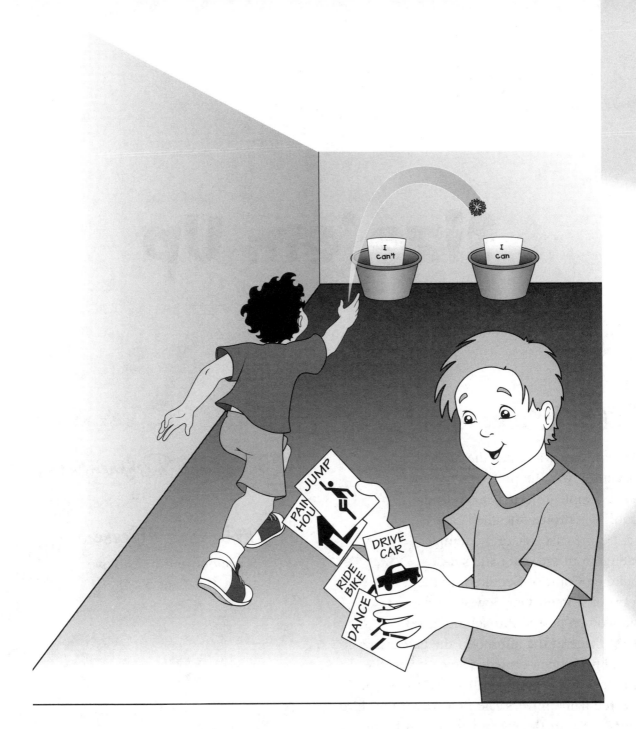

Game Wrap-up!

- **Who can do more, you or a little baby?** *(I can.)* **Why?** *(Let the children explain their ideas.)*

- **Who is able to do more things, you or a grown-up?** *(a grown-up)* **Why?** *(Let the children explain.)*

God is able to do more things than a baby, more than you, and more than a grown-up. God can do anything! That's why Jesus could raise Lazarus from the dead.

Dear God, You are very great. I know You can do big and hard things that no one else can do. Thank You for helping us when we need help. We love You. In Jesus' name we pray, amen.

Size 'em Up

Bible Background

The gate that was given the name "Beautiful" was the preferred entrance to the temple in Jerusalem and was probably a bronze-sheathed gate. It was on the east side of the temple leading from the outer and surrounding Court of Gentiles into the Court of Women. Only Jewish men and women passed through the gate.

At three in the afternoon the gate area would have been crowded since it was the time for the evening sacrifice and the second of three daily prayers. The first was at the third hour or 9 a.m., the second at the ninth hour or 3 p.m., and the third prayer at sunset. It was a good time for a Jewish beggar to show up. Jews of that time gave money to beggars to earn merit with God.

Peter and John did not have money to give but gave what they did have—Jesus. Jesus healed the man. John, and especially Peter, were merely the conduits to help the man act upon his faith and the healing. Peter helped the man get up—the first time in 40 years. It was the man's faith in the name of Jesus (see Acts 3:16), not Peter's touch or help, that healed. However, touch and action are both powerful ways that Jesus helps us to help others because both convey one's faith.

Observers were filled with "wonder and amazement." This was a common reaction to Jesus' miracles throughout the Gospels.

You may not heal another person, but you can help others with Jesus' help. How can you help the children in your class today?

Scripture Reference:
Acts 3:1–10

Memory Verse:
Serve one another in love.
Galatians 5:13

Teacher Tips

"Size 'em Up" develops helpful attitudes within preschoolers so they are ready to help others when it is time to pick up things. The game is structured just a bit to put blocks away in an orderly fashion. This part of the activity builds skills of visual comparison needed for sorting and also the children's finger dexterity.

When collecting the supplies, try to find small, medium, and large boxes that will neatly contain your small, medium, and large blocks. Don't be concerned if your blocks do not fit perfectly. Some open space allows room for fingers to move blocks to arrange them in the box.

In the first few experiences with this game, allow time for the children to compare the sizes of the boxes and blocks and talk about the size differences before you ask them to begin sorting the blocks into the boxes. Once preschoolers start moving and doing, they tend to keep going.

During every round of play, watch the children look, and wait while they think and work with the blocks. There will be plenty of cognitive work and movement going on. When the children finish, talk about what they did, all the abilities they used, and how Jesus gave us those skills for helping others when it is time to pick up things and put them away neatly.

Get It Together

- ☐ 3 boxes (1 small one such as an empty box for checks, 1 medium such as an empty box for greeting cards, and 1 larger box such as a shoebox)
- ☐ Numerous wooden blocks in 3 sizes (small about 3/4" per side, medium about 1" per side, and large about 1½" per side)
- ☐ Plastic storage container with lid for boxes and blocks listed above
- ☐ Permanent marker

How to Assemble

1. Collect the three boxes and numerous wooden blocks in a plastic container and label, "Size 'em Up: helpfulness, sorting, spatial organization, finger dexterity."

How to Play

1. Put out the three boxes and spread the wooden blocks randomly in front of the children.

2. Have the children place the three boxes in easy reach and begin sorting blocks according to size into a corresponding small, medium, or large box. Children may work together all at one time, individually sort and pack a specific size block, or take turns to help place all blocks.

3. Once completed, empty boxes and repeat step 2.

Game Wrap-up!

• **What things sometimes need to be picked up and put away at your house?** *(toys, clothes, dishes, etc.)*

• **Who picks things up at your house?** *(Mommy, Daddy, big brother, etc.)*

• **What can you do to help?** *(I can pick up my toys, put away my shoes, etc.)*

Jesus helps us help others by giving us eyes to see things that should be picked up and by giving us hands and fingers for putting things away neatly. Jesus is happy when we help others. Let's ask Him to help us help others.

Dear Jesus, thank You for giving us abilities we can use to help others. Please help us do our best to be willing to help when others have a need. We love You. In Your name we pray, amen.

Shape Match Relay

Bible Background

The early church had a deep sense of unity. This sense led to sharing their personal possessions with those in need (Acts 2:45). Some of the believers voluntarily sold their possessions to help meet the needs of the group. The money was then laid at the feet of the apostles. This practice came from an old custom. Property was laid at the feet of its new owner as a sign of a transfer in ownership.

At that time, Palestine was in an economic depression due to famine and political unrest. There may also have been economic and social sanctions against early Christians. So the early Christians were no strangers to stress. Their belief in Jesus often led to persecution and isolation.

The Holy Spirit powered the love and harmony experienced in the early church. He kept the experience of being with Jesus real. He is the same Spirit that dwells in today's believers. That means that the sharing, caring relationships of Acts can be a reality for you today.

Ask God to reveal to you ways to foster the spirit of sharing and unity within your own church relationships.

Scripture Reference:
Acts 4:32-37

Memory Verse:
Let us do good to all people.
Galatians 6:10

Teacher Tips

"Shape Match Relay" engages children to use their thumbs and fingers together to open the clothespins while matching colors and shapes. The physical component strengthens pincher muscles and develops hand and finger control. This helps prepare children's hands for many tasks including using a pencil.

Learning the names and characteristics of various shapes helps prepare the children for math skills. While the children pass and share shapes you can engage them in talking about how Jesus likes us to share.

Get It Together

- ☐ 10 jumbo clothes pins about 6" long
- ☐ Craft foam in orange, red, blue, green, purple, and yellow
- ☐ Scissors
- ☐ Plastic storage container

How to Assemble

1. Cut craft foam to make several shapes in various colors: triangles, circles, squares, diamonds, and rectangles.

2. Collect your clothespins and shapes into a resealable plastic container labeled, "Shape Match Relay: sorting, matching, finger dexterity."

How to Play

1. Open your game container and place all the shapes on a table.

2. Give each child a clothespin.

3. Line children up side-by-side going out from the table and place the empty container by the last child in line.

4. Tell the children they are going to play a sharing relay and that they have to use their clothespins to pick up the shapes. Have children practice opening and closing their clothespins.

5. When you say go, have the first child in line pick up one shape from the table using the clothespin and pass it to the next child in line.

6. The second child will pass the shape to the third child and so on until the last child in line drops it in the empty container.

7. Repeat after having children switch places along the line if desired.

8. As children play, emphasize how Jesus is happy when we share.

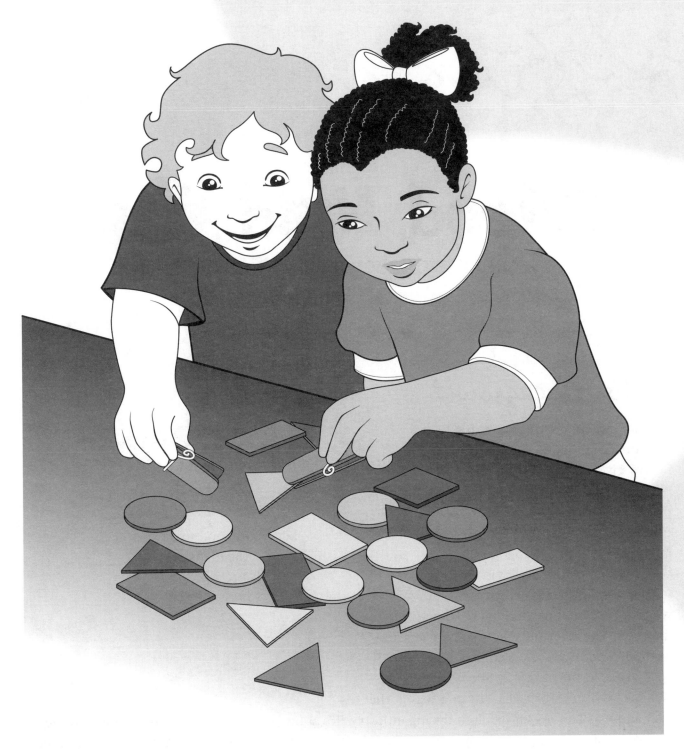

Game Wrap-up!

- **Who shared in the early church?** *(everyone)*
- **Were the people happy to share?** *(Yes.)*
- **What can you share?** *(toys, snacks, hugs, etc.)*

People in our families can help us learn to share like Jesus wants us to. We don't have to have a lot to share. Jesus is happy when we share whatever we have.

Dear Jesus, thank You for teaching us how to share. We love You. In Your name we pray, amen.

Friend Hand Slap

Bible Background

It is not strange that Paul and his missionary companions went to a nearby river to look for people praying. People often selected places of prayer outdoors near running water especially in communities without a synagogue. A community needed 10 Jewish men to establish a synagogue. Apparently they weren't present, but there were some Jews in the town. The river outside the city gates and just a bit south was the Gangites River.

Lydia sold purple cloth. She was from the Hellenistic district of Lydia. Thyatira was in that district and was famous for its cloth dyeing industry. Royal purple was one of many colors produced.

Lydia was a Gentile "worshiper of God" (Acts 16:14). This means she believed in God, revered Him, and followed His moral teachings in the Jewish Scriptures, but she was not a full convert to Judaism nor did she know the Gospel. After the Lord opened her heart she became a believer in Him. Out of gratitude for Paul's initiative to share the Gospel, Lydia returned the best favor she could to demonstrate kindness—she hosted Paul and his traveling companions in her home.

Being nice to others is motivated by Jesus' love. It is showing His love to those around you. How can you and your class "be nice" to others in your church?

Scripture Reference:
Acts 16:13-15

Memory Verse:
Let us do good to all people.
Galatians 6:10

Teacher Tips

"Friend Hand Slap" lets the children search and sort colorful people to match up pairs that are dressed alike. Then children "slap" the hands of matching pairs to attach them as friends that are nice to each other.

The game activity provides children the opportunity to develop skills for identifying the similarities in patterns—an important process for success in reading and math. Sentences, stories, and numbers can follow various patterns.

Attaching and separating hook and loop fasteners helps develop fine motor skills with the hands. Finger dexterity equips children for self-sufficiency. Preschoolers will enjoy making sure each friend is paired up because they are beginning to understand the fun of doing things with a friend and being included.

Get It Together

- ☐ 20 tongue depressor-type craft sticks
- ☐ Wallpaper or fabric in 10 different colorful but small patterns
- ☐ Tan or brown craft foam
- ☐ Scissors
- ☐ Craft glue
- ☐ Self-adhesive hook and loop fasteners
- ☐ Black permanent marker
- ☐ Brown pencil or crayon
- ☐ Large resealable bag

How to Assemble

1. Draw happy faces and hair on one end of each tongue depressor craft stick. Shade some of the faces with brown crayon or pencil.

2. Cut 10 different fabric or wallpaper pieces 3" x 4". Cut each 3" x 4" piece in half to make 10 pairs of 1½" x 4" material that show matching patterns.

3. Wrap and glue wallpaper or fabric pieces around each craft stick just below the faces you drew as if adding colorful or patterned clothing.

4. *Optional: Wrap fabric tightly along stick to make boys in pants, and wrap top of fabric only leaving the bottom loose as a dress for girls. Be sure to let the matching pattern show.*

5. Cut 40 strips of craft foam ½" x 2" and trim an open hand at one end of each strip to make arms with hands.

6. Glue two arms onto the back of each craft stick to make stick people.

7. Attach self-adhesive hook and loop fasteners to the back of one hand on each person so matching people can be attached together side-by-side with both heads facing the same direction.

8. Collect all 20 stick people into a large resealable bag labeled, "Friend Hand Slap: sorting, matching, finger coordination."

How to Play

1. Open your game bag and spread the stick people in front of the children.

2. Show the children how to attach the hook and loop fasteners on the backs of hands.

3. Ask the children to sort the stick people to connect the friends in clothes with matching colorful patterns by pressing or slapping their hands together to attach the hook and loop.

4. Talk with the children about how Paul and Lydia showed they were friends by being nice to each other. Separate the people and play again or pack the game away.

Game Wrap-up!

- **Who are your friends?** *(Let the children name their friends.)*
- **What are some ways you show people that you are their friend?** *(hold their hands, share, talk, play together, etc.)*

Sometimes it takes work to be a friend. When we are nice to our friends we are showing them Jesus' love. You can share, listen to, and be nice to your friends.

Dear Jesus, please help us be nice to our friends. Give us ways to be kind and caring to them. We love You. In Your name we pray, amen.

Dish It Out for Jesus!

Bible Background

Paul and Silas were beaten and then locked into stocks in an inner cell of the jail at Philippi. These measures were intended to break their spirits and assure them that they could not escape. While many would withdraw into themselves in defeat, Paul and Silas prayed and sang aloud to God in the clear hearing of the guards and prisoners. Their actions showed their love for Jesus and eventually benefited others.

The earthquake was God's action. The jailer acted quickly intending to take his own life to avoid the shame and distress he would have inevitably felt before being killed for allowing prisoners to escape.

Paul and Silas undoubtedly saw the guard through the open door and immediately understood from common knowledge what he was about to do and why. Paul and Silas acted quickly to intervene, again demonstrating their love for Jesus through action for the benefit of others.

Coming so close to the end of his life, the jailer wanted to know about the way to salvation. Paul and Silas responded—showing in yet another way their love for Jesus.

How can your actions, as you teach today, show that you love Jesus?

Scripture Reference:
Acts 16:25–36

Memory Verse:
Serve one another in love.
Galatians 5:13

Teacher Tips

"Dish It Out for Jesus!" is a simple activity that teaches children a way to show they love Jesus by helping to set a dining table for a family meal. In addition to equipping children for helping their families in a practical way, the activity builds organizational skills and teaches children to duplicate patterns. These are lessons that serve us throughout life.

Teach the importance of the children sitting or perhaps kneeling on a chair in front of the place they are setting up—not standing on chairs.

Reinforce that we hold each piece firmly while moving and placing it to set the table, whether using safe and unbreakable plastic dishes as for this activity or if working with pottery and glass materials when at home. When the table is set, talk with the children about things they can do to show they love Jesus.

Get It Together

- ☐ 4 unbreakable glasses
- ☐ 4 unbreakable small plates or saucers
- ☐ 4 sets of plastic, heavyweight flatware (spoons, knives, and forks)
- ☐ Optional alternative: plastic picnic set for 4
- ☐ 4 12" x 18" craft foam sheets or felt pieces
- ☐ 4 cloth squares 4" x 4" or high-quality paper napkins
- ☐ Permanent marker
- ☐ Optional: foam stickers
- ☐ Shopping bag, picnic basket, or large box with a resealable lid

How to Assemble

1. Place a glass in the upper right corner of a 12" x 18" sheet of craft foam. Put a plate in the center, napkin to the left of the plate with a fork on top of the napkin, and a knife and spoon to the right.

2. Trace around each piece to complete a table setting placemat. After tracing the napkin, remove it and trace the fork as if on top of the napkin. The tip and tail of the fork should extend above and below the napkin.

3. Repeat steps 1 and 2 to make three more placemats.

4. Optional: Decorate placemats with stickers.

5. Collect glasses, plates, flatware, napkins, and placemats in a shopping bag, picnic basket, or resealable box labeled, "Dish It Out for Jesus!: helpfulness, pattern duplication, matching, organizational skills."

How to Play

1. Unpack the activity materials and place them on a table so the children can easily reach the pieces.

2. Give each of four children a placemat. Explain how the outlined shapes match the dishes and eating tools on the table. Tell the children to use the materials to set up their eating places by matching the pieces to the outlined shapes.

3. Optional: For three advanced children, have the children work together to arrange materials on one marked placemat for all to use as a model. Give each of the three children a blank placemat (with the marked side down). Have the children use remaining dishes and materials to copy the model place setting.

Game Wrap-up!

- Can you name one way we can help our family members at home? *(set the table, feed the dog, put away toys, etc.)*
- Who else can you help beside your family at home? *(friends, teacher, etc.)*
- What are other things we can do to show we love Jesus? *(share, give hugs, pray, etc.)*

We know Jesus loves us because He said so and showed His love for us. We can show that we love Jesus by serving one another. Serving one another means helping others. Let's thank Jesus for loving us and ask Him to help us show we love Him.

Dear Jesus, thank You for loving us. Please help us do things that show we love You. In Your name we pray, amen.

Topic Index

110

Scripture Index

Bible Games That Teach Correlation Chart

Title	Page	Scripture Reference	David C Cook LifeLinks to God New Life College Press Reformation Press Wesley Anglican	Echoes The Cross
Scared, Mad, Sad, Glad	82	John 4:4–26	Unit 13 Lesson 1	Unit 13 Lesson 1
Friend Jesus	78	Luke 19:1–10	Unit 13 Lesson 3	Unit 13 Lesson 3
Lunch for a Bunch	86	John 6:1–14	Unit 14 Lesson 5	Unit 14 Lesson 5
Shape Hunt	70	Luke 15:1–7	Unit 14 Lesson 7	Unit 14 Lesson 7
Can Do—Can't Do	90	John 11:1–45	Unit 14 Lesson 9	
Splash and Fly	6	Genesis 1:6–10, 20–23	Unit 15, Lesson 11	Unit 15, Lesson 11
Stripes, Splots, and Polka Dots	10	Genesis 1:24–25, 30; Psalm 104:10–12, 17–18	Unit 15, Lesson 13	Unit 15, Lesson 13
Birthday Count	66	Luke 2:1–7	Unit 16, Lesson 2	Unit 16, Lesson 2
Escape to Egypt	42	Matthew 2:7–23	Unit 16, Lesson 4	Unit 16, Lesson 4
Body Hop	14	Genesis 1:26–29, 31; 2:7–8, 21–23	Unit 17, Lesson 6	Unit 17, Lesson 6
What to Wear?	18	Genesis 1:27; 2:7; 3:20; 4:1–2, Psalm 139:1–6, 13–18	Unit 17, Lesson 8	Unit 17, Lesson 8
Prayer Chain	30	1 Kings 8	Unit 18 Lesson 10	Unit 18 Lesson 10
Coin Lineup	62	Mark 12:41–44	Unit 18, Lesson 12	Unit 18, Lesson 12
Anytime Jesus	50	Matthew 19:13–15	Unit 19, Lesson 1	Unit 19, Lesson 1
Build a Story	46	Matthew 7:24–29, Luke 6:46–49	Unit 19, Lesson 3	
Praise Parade	54	Matthew 21:1–11	Unit 20, Lesson 5	Unit 20, Lesson 5
Size 'em Up	94	Acts 3:1–10	Unit 20, Lesson 7	
Dish It Out for Jesus!	106	Acts 16:25–36	Unit 20, Lesson 9	Unit 20, Lesson 9
Shape Match Relay	98	Acts 4:32–37	Unit 21, Lesson 11	Unit 21, Lesson 11
Friend Hand Slap	102	Acts 16:13–15	Unit 21, Lesson 13	Unit 21, Lesson 13
Lead the Way	26	Genesis 41:28–55	Unit 22, Lesson 2	Unit 22, Lesson 2
Feed the Sheep	38	Psalm 23	Unit 22, Lesson 4	Unit 22, Lesson 4
Heart Break	22	Genesis 27:41a; 32:9–21; 33:3–11	Unit 23, Lesson 6	Unit 23, Lesson 6
Color Bingo	34	2 Kings 4:8–11	Unit 23, Lesson 8	Unit 23, Lesson 8
Fear Squish	58	Mark 4:35–41	Unit 24, Lesson 10	Unit 24, Lesson 10
Thanks!	74	Luke 17:11–19	Unit 24, Lesson 12	Unit 24, Lesson 12